IMAGES
of America

WYCKOFF

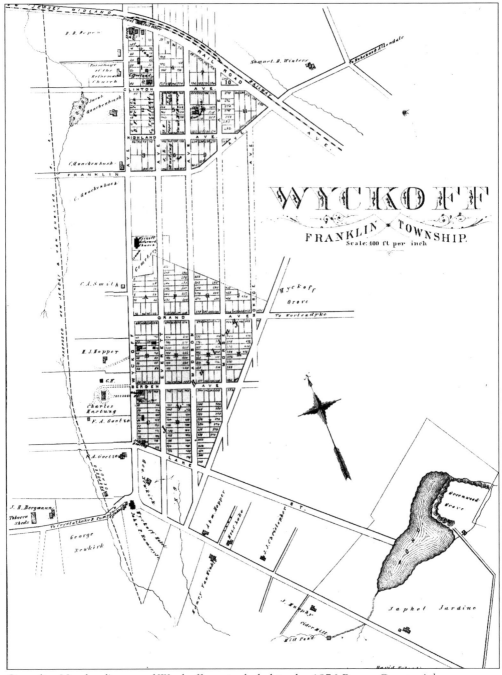

Cornelius Vreeland's map of Wyckoff was included in the 1876 *Bergen County Atlas*.

IMAGES
of America

WYCKOFF

David R. Brown with Bob Traitz
and the Wyckoff Historical Society

ARCADIA

First printed in 2003.

Published by Arcadia Publishing,
an imprint of Tempus Publishing, Inc.
2A Cumberland Street
Charleston, SC 29401

Printed in Great Britain.

Library of Congress Catalog Card Number: 2002112612

For all general information, contact Arcadia Publishing:
Telephone 843-853-2070
Fax 843-853-0044
E-mail sales@arcadiapublishing.com

For customer service and orders:
Toll-free 1-888-313-2665

Visit us on the Internet at www.arcadiapublishing.com.

CONTENTS

Acknowledgments 6

Introduction 7

1. Early Stone Houses 9

2. Farms and Country Living 21

3. Old Structures 33

4. Community Life 51

5. Downtown 97

6. Churches and Places of Rest 119

ACKNOWLEDGMENTS

We would like to thank the many people who stretched their memories or loaned photographs to help make this book. Our first thanks go to Richard and Florence Turner of Richard Butler Turner Photographers, without whom the book would not have been possible. Other photographs came from (in random order) Carolyn and Joe Landi, the Gallenkamps, Alice Cole, the Anderes family, the Bracket family, Sebastian Gaeta Estate, the Dambach family, Joan Rickettson, Bruce Scott, Ken Depew, Lillian Myers Thomas, Barbara Perdue, Ed Van Duzer, Margaret and Curt Welch, Warren Seitz, John Baumgartner, Wyckoff Police Department, Wyckoff Library, Friends of the Library, the Zabriskie House, Susie Bell, Pete Cantalina, Paul Ciancia, Margaret Jane Budd, Judy Abma, Christina Nemec, Gordon and Peggy Stanley, Richard Lynch, and the Wyckoff Reformed Church. We also wish to thank anyone else we may have missed. Finally, thanks go to the Brown and Traitz families for putting up with us during this quest.

All proceeds from this book will go to the Wyckoff Historical Society.

Introduction

The Wyckoff area was inhabited by Lenni Lenape Indians from around A.D. 100 to A.D. 1600. The first white settlers appeared in the 1600s. The British Duke of York claimed the land and deeded all of New Jersey (also called Nova Caesaria) to Sir George Carteret and Lord John Berkeley in 1664. Carteret owned the portion known as East Jersey. After he died in 1679, the land was sold to 12 Quaker proprietors in 1682, who then split their shares to add 12 additional owners. The Earl of Perth was one of the early proprietors, and his name appears on the earliest deeds in the Wyckoff area. The Ramapo Tract was a large area of land that encompassed the towns of Allendale, Franklin Lakes, Glen Rock, Ho-Ho-Kus, Mahwah, Midland Park, Ramsey, Waldwick, and Wyckoff.

Land purchases were usually made from the proprietors but also from the Native Americans for clear title. Peter Sonmans granted titles to some of this land, claiming to be an agent for the proprietors, but the proprietors denied his authority, and it took some number of years before all the titles were cleared. Wyckoff was then part of New Barbadoes, which then formed Saddle River Township and consisted of all of Bergen County west of Saddle River.

The first known settlers in Wyckoff are believed to have been John and William Voor Haze, two brothers who purchased 550 acres in 1720. The next known settlers were Barent Van Horn and his wife, Rachel, who settled in 1742. Their house is known today as the Van Horn–Ackerman House. In 1771, a portion of Saddle River split off to become Franklin Township. It was named after Gov. William Franklin, son of the famous Benjamin Franklin. Other settlers came from New York and Bergen (now Jersey City) to buy farmland. By 1775, about 100 families lived in the Franklin Township, with about 20 to 30 families living in the Wyckoff area. During the Revolutionary War, the Wyckoff area was not affected much, probably due to the sparse population and no major troop movements through the town. Local resident John Van Blarcom served as an officer in the Continental army.

Franklin Township continued to grow slowly as more settlers started farming, dairying, and milling. In 1832, Franklin Township was listed as having 18 gristmills, 13 cotton mills, and 25 sawmills and occupied an area of 45,000 acres. J.H. Bergman had tobacco sheds and dried, cured, and exported tobacco to Germany c. 1870.

Most of the early settlers were Dutch, and the first church in the area was the Ponds Dutch Reformed Church, started in Oakland in 1710. The church was a strong influence on the area, and in 1806, local residents built their own church. The Wyckoff Dutch Reformed Church

became an important source of social activities, including cake and strawberry festivals, oyster suppers, and church picnics.

The church was the source of education for the children until the first school was established c. 1800. There were several small schools that existed in those early days, but the earliest records mention three schools in 1869, including the Sicomac Schoolhouse. Schooling was apparently the source of many disputes and a cause of some towns to secede, such as Ho-Ho-Kus, which formed in 1849.

John Ramsey's hotel was a popular spot for entertainment. Country dances were held there, and the hotel's liquor and wines were known throughout the county. Carriage races were held along Wyckoff Avenue, and sleigh riding in winter was also popular.

When the railroad came to town in 1870, the area was forever changed. The train ran from Jersey City through town and continued north to Butler and connected to lines that went as far as the Pennsylvanian coal fields. The trains made it easier for residents to get jobs in the urban areas and brought people from the cities to Wyckoff to vacation in the fresh country air. There were several boardinghouses that catered to the weekend and summer visitors.

After a large fire in 1905, people in the community got together and formed a volunteer fire department that became functional in 1907. The Wyckoff Police Department was formed in 1922 to replace several marshals and a county constable. The police and volunteer fire departments have always been a source of pride among residents. Wyckoff has always had enthusiastic and numerous social and civic organizations.

Hamlets of Franklin Township continued to form their own towns. Ho-Ho-Kus split off in 1849 and was followed by Ridgewood, Midland Park, Oakland, and finally Franklin Lakes in 1922. Franklin Township was then renamed Wyckoff in 1926. The source of the name Wyckoff is still a source of some controversy, but the generally agreed origination is from the Native American word *Wikhoff*, or *Wikoff*, meaning "high ground." The name of the Sicomac area comes from a Native American word meaning "happy hunting ground," where it is believed some of the Lenni Lenapes are buried.

In the 20th century, the town population grew slowly, reaching only about 1,000 residents in 1910. The town was starting to develop a more residential character, with the first housing development built in the 1920s. The downtown commercial district continued to grow, and schools were added for the increasing population. Today, there are the Lincoln, Sicomac, Washington, and Coolidge grammar schools, Eisenhower middle school, and the Ramapo and Indian Hills regional high schools. Wyckoff has also been home to many diverse religious backgrounds, and today, we have 14 houses of worship.

People have always been drawn to Wyckoff because of its location, appeal, family atmosphere, and dedication to its community, including a first-rate education system. To the casual beholder, the town looks like the modern suburb, but with some careful observation, there are places and buildings that are full of history. Not everything that should have been preserved was, but photographs make a lasting memory of days past.

One
EARLY STONE HOUSES

One of the influences of the early Dutch settlers is the method of house construction. The Dutch settlers realized the durability in building houses partially out of stone. Some of the stone used was red sandstone, which is easily cut into rectangular forms. This type of stone was not as common in Bergen County as in other areas, so many of the stones we see in the foundations are local rubble-type fieldstones that were turned up by plowing fields. The stones were selected carefully to fit using little mortar, and bits of clamshells and goat hair were often added to the mortar to make it go farther. The roofs were also built better than those on the average frame houses. On the inside of the house, the outside walls were covered in various materials, such as plaster filled in with mud and stones. Many of the homes were built with Dutch beehive ovens, which were thick brick enclosures for baking.

Most of the stone houses pictured are listed in the Bergen Stone House Survey, the National Register of Historic Places, and the federal Historic American Building Survey. Although they have had additions or modifications through the years, the original structures remain intact. Once listed on the National Register of Historic Places, the house is protected from federally funded projects, such as highway construction, and is also eligible for federal funds for restoration or preservation.

The importance of these houses is that they are some of the only physical links to the past and to the contributions of the early owners. Many of the owners of these houses have taken it upon themselves to preserve the original parts of the homes and perform restorations that will not diminish their historical value. Unfortunately, the public does not get to view the current insides of these houses except for an occasional house tour. The exception is the Van Voorhees-Quackenbush-Zabriskie House, which can be visited on Friday mornings during the school year. Volunteers who are knowledgeable about the house and gardens are available to answer questions from the public about the house.

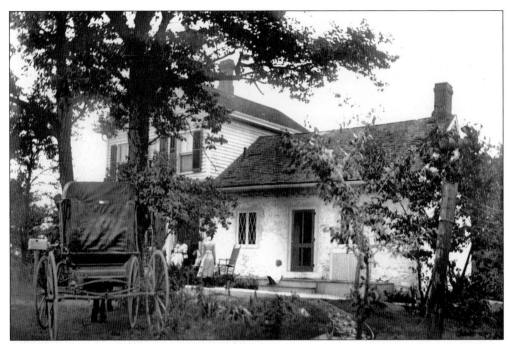

Tracing its origins to before the Revolution, the Albert Van Blarcom House stands on Crescent Avenue. The main portion of the house was built c. 1830. It is later mentioned in John Van Blarcom's will in 1850. In its early days, the house was part of the Cranberry Vley Plantation, which consisted of 140 acres of cranberry bog, mostly to the east of the house. In 1851, it was sold to Adam Folley, and it was sold to J.M.B. Frost in 1906. This photograph was taken c. 1900.

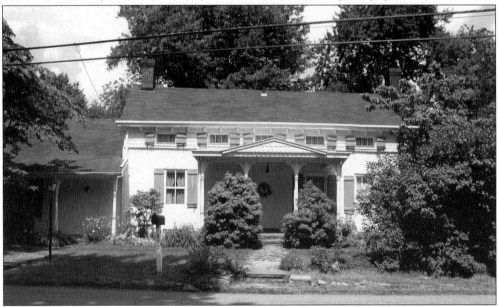

The Folly-Bush House, at 310 Crescent Avenue, was built on land purchased by Abraham Blauvelt in 1787. The house was built sometime before 1861, when Folly is recorded as the owner. It was later owned by the Bush family. Notice the eyebrow windows in the upstairs. In that era, homes were often built with one and a half stories.

The Van Blarcom House, at 131 Godwin Avenue, was built by Peter Van Blarcom in 1740 on property originally sold to Johannis Van Zile in 1745. Nicknamed "Oldstone," it is considered a sister house to the Terhune house nearby. Stephen Terhune is also listed as a later owner of the home.

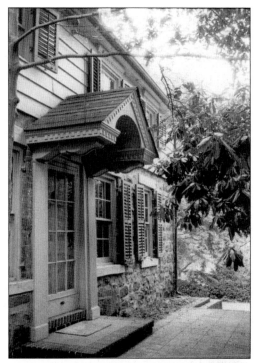

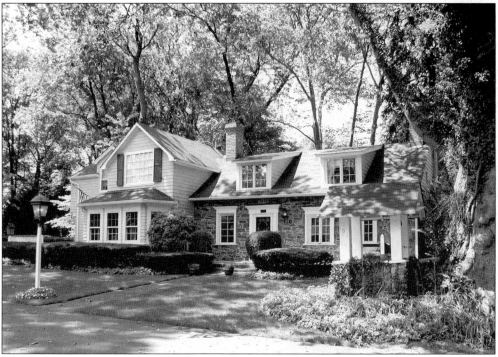

At 161 Godwin Avenue, the Terhune house was built in the early 1700s with 24-inch-thick walls that were mortared with mud, pig bristle, and clam shells. The main pilings consist of pine tree trunks. You can see the original one-room structure of the house on the right. Additions were built in 1877, 1895, and 1960. The Van Blarcom family bought it in 1895.

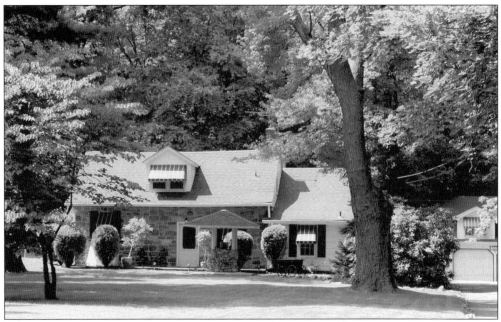

The Cruse-Hossington House, at 301 Newtown Road, sits well back from the current road. Built in 1798, it is a faithful preservation of the original Dutch farmhouse. F.C. Cruse is listed as the owner in 1861, and Richard Hossington is listed as the owner in 1876. The restored stone well sits in front.

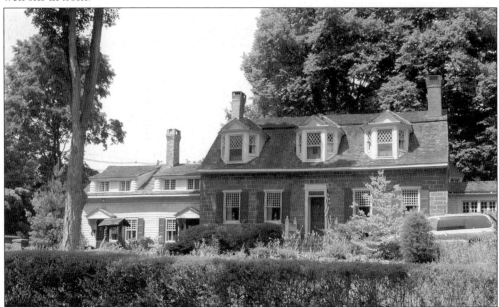

This large home, known as the Cairns-Whiten-Blauvelt-Dambach House, was built by Douglas Cairns c. 1770. In 1779, he married a Dutch girl and operated mills in the ravine across the street. The third owner, James Blauvelt, was in the Revolutionary War and was noted for his fight at the Battle of Liberty Pole, near Englewood. He established the successful Blauvelts Mills. A later owner, Judge Stevenson, produced a mold of butter called Depe Voll, meaning "deep brook," in the early 1800s.

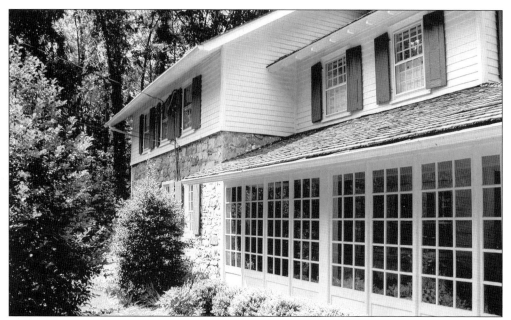

In the 1700s, the Van Houten–Ackerman House was built at 480 Sicomac Avenue. Also called Wellsweep, it is purported to be the first Van Houten home in the area and was originally built as a one-room house. John Van Houten was the owner in 1859, and then the house went to Maria Ackerman, his sister. The kitchen still shows the old wooden beams attached by wooden pegs. A 20th-century owner added an old tenant building moved from Closter.

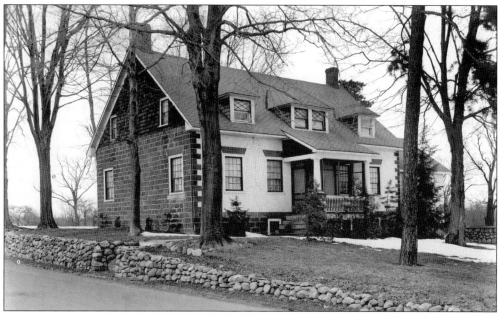

Some original foundations of the John C. Stagg House on Sicomac Avenue date to before 1747 and were built by Johannes Stagg, who bought 50 acres of land from Daniel Rattan. The main house was constructed between 1762 and 1797, and his son Cornelius Stagg or grandson John C. Stagg rebuilt the original portion in 1812. More alterations were done between 1867 and 1899. Cornelius served in the Bergen County Militia in the Revolutionary War.

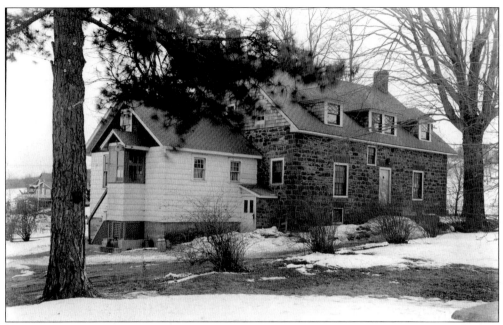

In this view looking southwest at the Stagg house, you can see the variety of construction used in the house compared to the front of the house. The original flooring was white pine planks on hand-hewn oak and chestnut beams. The roof beams are also hewn beams. It is reported that Cornelius Stagg ran a grocery store out of the basement in the early 1800s.

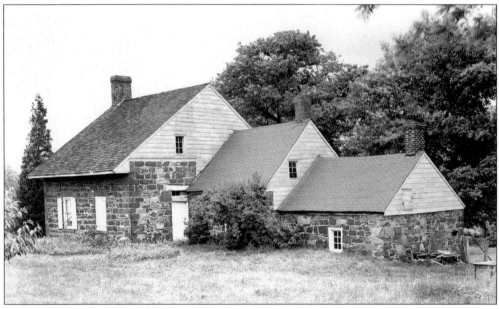

The Van Horn–Ackerman House style is referred to as a "telescope" house because of the way it starts with a small house and larger additions were built through the years. The smallest section was probably the original house, which was built from c. 1744 to 1750, with a sandstone foundation. Other larger sections were added during the years before the Revolution. Barent Van Horn and his family were British Loyalists, and there was a report of a raid on the house during the Revolution. This 1937 photograph shows the back of the house, at 101 Wyckoff Avenue.

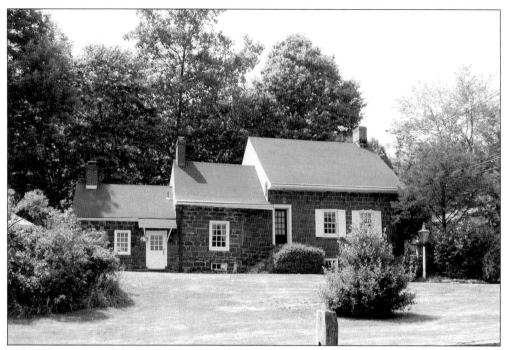

This is a current view of the Van Horn–Ackerman House. Although the house has had maintenance during its 200 years, it still is a quaint reminder of Colonial times, nestled in modern suburbia.

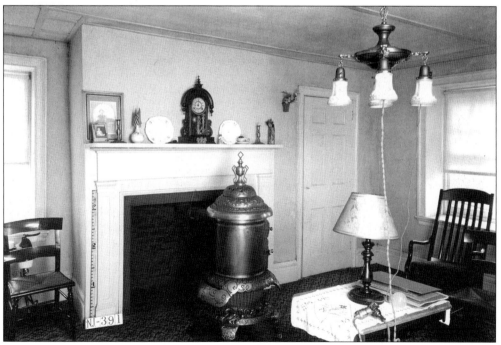

This 1937 photograph shows the interior of the Van Horn–Ackerman House. G. Ackerman is listed as the owner in 1861, and Robert Branford bought the house in 1870. Branford lived in the house until the 1940s. A stove has been added to the fireplace for warmth.

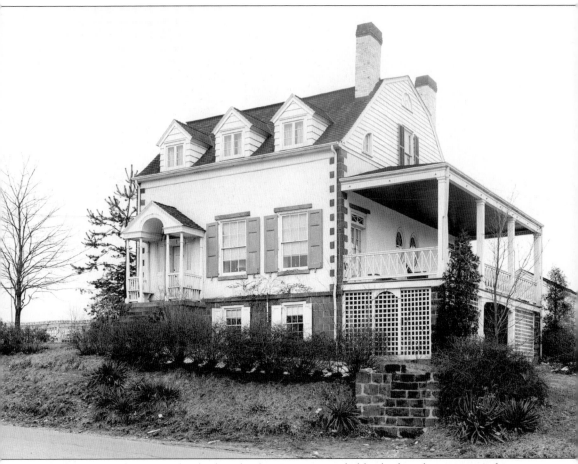

The Van Voorhees-Quackenbush-Zabriskie House is probably the best-known stone house in town. The original structure dates back to *c.* 1740, when it was built out of sandstone and fieldstones by William Van Voorhees (originally Van VoorHaze). His son Albert operated a store and tavern for travelers and the few families in the area. The original section of the house is now the dining room and part of the kitchen. This is possibly the oldest house in Wyckoff. A large addition was built in 1824 that included the gambrel roof. It remained in the Van Voorhees family until 1864. It was sold in 1867 to Uriah Quackenbush. This picture, taken in 1937, shows the view from Franklin Avenue. The last resident, Uriah's granddaughter Grace Quackenbush Zabriskie, donated the pond in front of the house and five surrounding acres to the town in 1963. She continued to develop extensive gardens until her death in 1973, when the house and all of its contents were willed to the town.

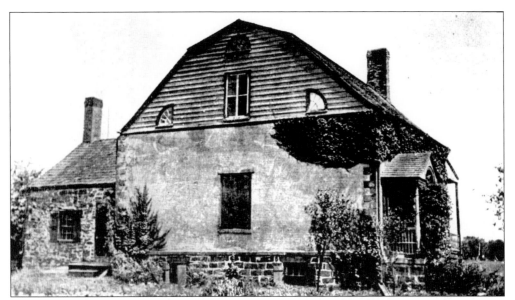

This is an early photograph of the Van Voorhees-Quackenbush-Zabriskie House taken from an old plate. The house was used as an inn during the Revolutionary War. Wyckoff was a kind of sanctuary from the war, which did not have a large effect on the area.

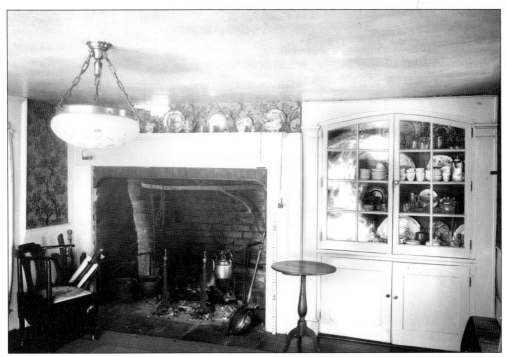

This is an interior view of the Van Voorhees-Quackenbush-Zabriskie House kitchen from 1937. Uriah Quackenbush held watermelon parties when the melons were ripe. Long tables were set up in the house, and friends and neighbors were invited over. The house is now a Wyckoff museum, open to the public on Friday mornings during the school year.

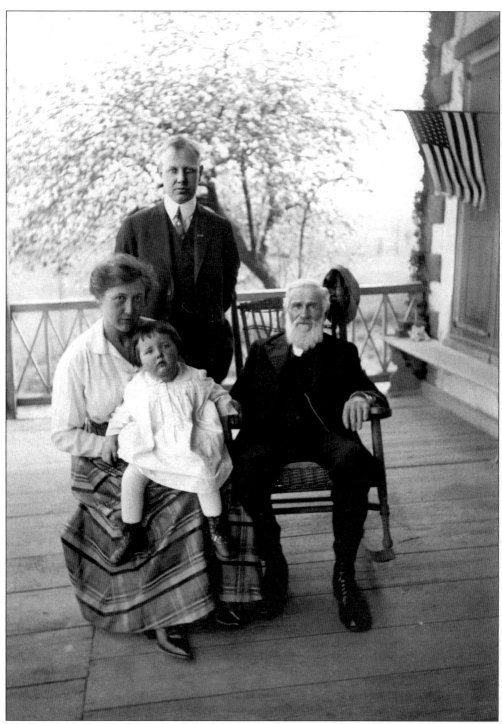

Seen here is Grace Marion Zabriskie on the lap of her mother, Grace Q. Zabriskie, with her father, John, and her great-grandfather Uriah Quackenbush. John was a longtime judge in town. Grace Marion Zabriskie bequeathed the Zabriskie house and pond to the town. Uriah lived in the house from 1867 to 1921. This photograph was taken c. 1912.

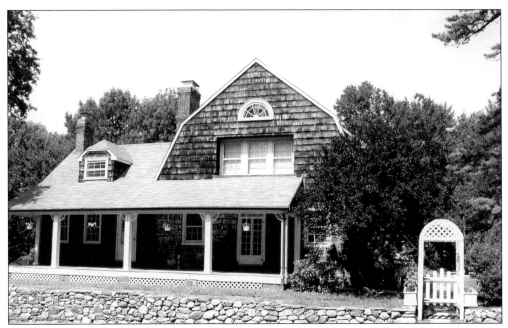

At 380 Wyckoff Avenue sits the house referred to as the Van Blarcom–Jardine House. The Dutch barn-style roof was not the original roof. The construction date is not known, but J. Van Blarcom is listed as the owner on the 1861 map of the area. Japhet Jardine is listed as the owner in 1861. A wooden cistern that was used to provide water for residents sits in the attic.

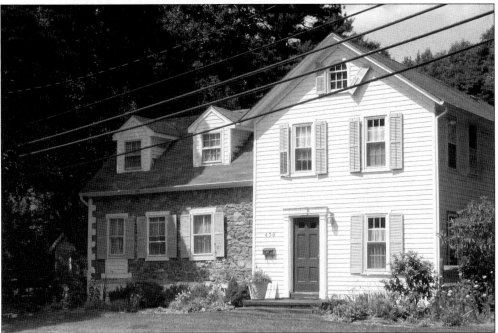

The Masker House was built *c.* 1780, possibly by Conrad Pulis. The land was purchased by John Ruttan, the other possible builder, in 1787. A two-story frame addition was added to the right of the original section. A. Masker is listed as the owner in 1861. The house sits at 470 Wyckoff Avenue.

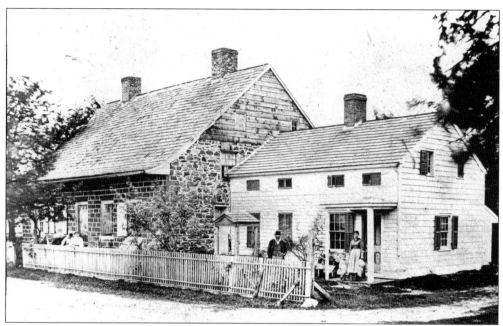

Although this building is known to residents as the Brownstone, its historical name is the Corines Quackenbush house or the Quackenbush Homestead. The house was erected in 1784 for John A. Van Voorhees and his wife, Sally, by his father. It was sold to Corines Quackenbush in 1840 and remained with the Quackenbush family until 1920, with alterations made in 1840 and 1870. This picture shows the Quackenbushes in the late 1800s.

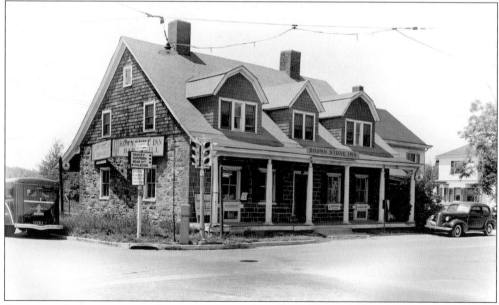

An interesting construction feature is that red sandstone was used, which must have been brought in from a distance because there was no local source. The Brownstone became a tearoom for the last few years of Prohibition, c. 1930, and after alcohol was legalized again, it became a restaurant and tavern. This picture was taken in 1941, before the enclosed back porch was added and the decorative fireplace woodwork was removed inside.

Two

FARMS AND COUNTRY LIVING

The early Wyckoff area contained many small farms, but only a few remain today. Farmers were drawn to the fertile farmland that sold for 18¢ to $1.75 an acre. Local farmers grew apples, corn, potatoes, strawberries, blackberries, raspberries, beans, peas, squash, and pumpkins. Poultry, sheep, and cows were also raised. The crops were sold at regional marketplaces, such as Hackensack and Paterson. The journey to the markets was over dirt roads and was long and tiring. When the Paterson market was going to relocate, the farmers banded together to form a local Grange to provide a united voice for farmers.

Other industries, including cider mills, gristmills, and sawmills, were tied to the local agricultural activities. Some of the well-known mills were Halstead gristmill off Brookside Avenue, Alyea's sawmill and mill off Wyckoff Avenue, and the Pulis sawmill and cider mill by Spring Lake.

During the years of World War II, the farms had to bring in women from the cities to work the fields because of the number of regular workers who were in the service. After the war, the suburban housing boom started, and the number of farms started to decline rapidly. The town still has three working farms, but there is always constant pressure from developers.

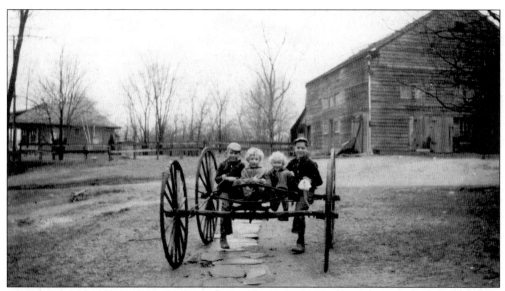

Abma's Farm, on Lawlins Road, can trace the barn back to 1790, when it was a farm owned by Daniel Yeoman. It was sold to George Fox in 1890. Barney Abma purchased it in 1933, and it has been in the family ever since. The barn in this 1940 photograph was constructed with post-and-beam construction and is one the best-preserved Dutch barns in the county. Four of Barney Abma's five sons are seen in the carriage.

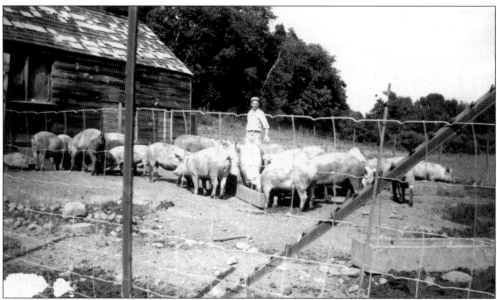

There was a small number of pigs raised on Abma's Farm, but the Henkel piggery run by Charles Jurgensen on Crescent Avenue produced up to 6,000 pigs a year to supply labs that made cholera vaccines c. 1903. Complaints from residents and rising land prices eventually forced the sale of the 80-acre farm to the county for use as a park in 1974.

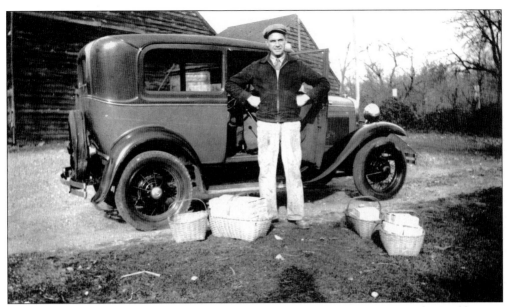

Barney Abma raised chickens, turkeys, and pigs. He is seen here in 1935 in front of his car, which he used to deliver eggs. The farm no longer delivers eggs but is still run by Abma family members, who still maintain a farm market.

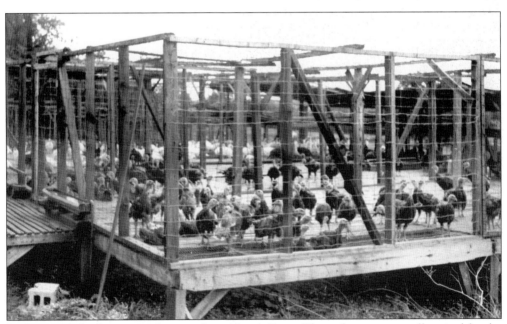

Turkeys and chickens were also raised on Abma's Farm. The turkeys were usually raised for the fall and winter seasons. For many years, Wyckoff was a large poultry producer.

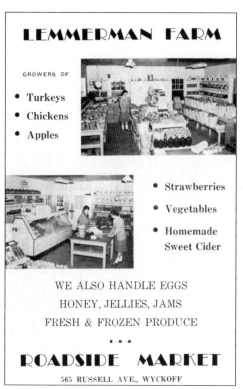

LEMMERMAN FARM

GROWERS OF

- **Turkeys**
- **Chickens**
- **Apples**

- **Strawberries**
- **Vegetables**
- **Homemade Sweet Cider**

WE ALSO HANDLE EGGS
HONEY, JELLIES, JAMS
FRESH & FROZEN PRODUCE

ROADSIDE MARKET
565 RUSSELL AVE., WYCKOFF

Seen here is a 1950s advertisement for Lemmerman Farm. The farm stand was opened in 1939, just before the war.

This was the farm stand of Lemmerman Farm that was situated on Russell Avenue where Temple Beth Rishon now stands. The 35-acre farm was started in 1902 and was purchased by the Lemmermans from Cornelius Quackenbush in 1921. The roadside stand was frequented by people who drove out from the cities and surrounding areas to go to the farm store.

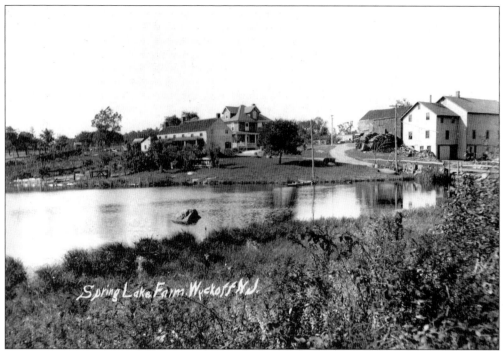

Spring Lake Farm was established in 1888 by Peter S. Pulis. The Pulis farm contained a poultry farm, a sawmill, a cider mill, and an icehouse. This is an early photograph of part of the farm.

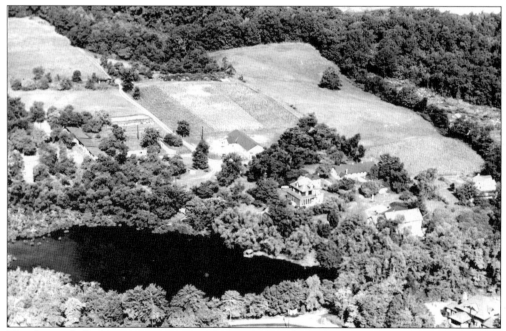

The Spring Lake Farm is seen surrounding Pulis Pond. The farm and the lake are gone now, replaced with Spring Meadows Condominiums.

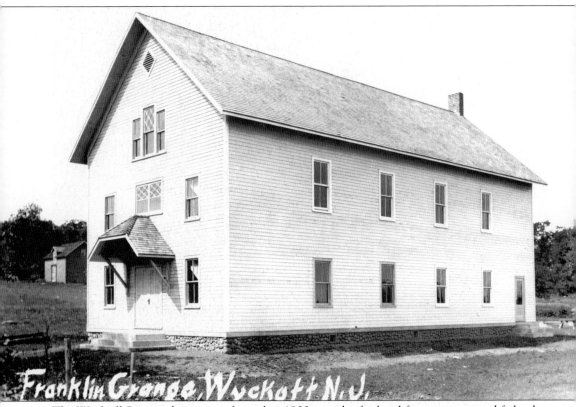

Franklin Grange, Wyckoff N.J.

The Wyckoff Grange chapter was formed in 1903 in order for local farmers to try and fight the farmer's market relocation in Paterson and to act as a common voice and lobby for local farmers. The building was constructed in 1913. It was used by many local organizations and was well known for Saturday night round and square dances. The Grange building stands at the corner of Fairview Place and Franklin Avenue and was converted to private residence by an architect in 1970.

Lillian Bates and her brother Melvin are seen with Dolly the cow on the Bates farm on Sicomac Avenue in this 1902 photograph. The Bates farmhouse still sits in front of the Barn restaurant.

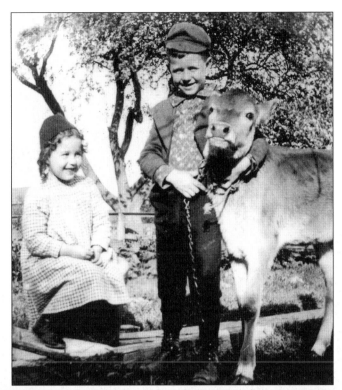

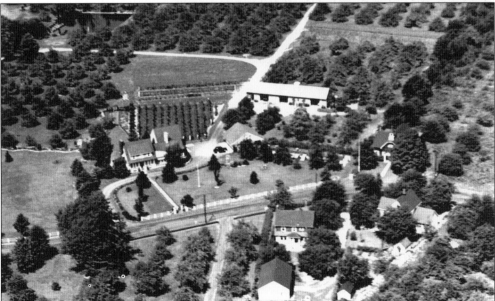

Now known as Russell Orchards, this farm was originally 33 acres that were sold to John Duryea in 1878. Edward Russell purchased the farm in 1906 and ran it as a wholesale apple farm. It was sold to Dorothy Long in 1941, and in 1950, it functioned as a retail farm. Today, it is owned and operated by Mark Cole and Paul Burke. This 1938 view shows the original farmhouse, which still stands off Sicomac Avenue. In the middle right is the original Sicomac Schoolhouse, where the Sicomac firehouse stands today.

Russell Avenue runs from top to bottom. At the left is Lemmerman Farm and the Lemmerman swimming hole. In the center of the photograph is a swimming area made by Grace Russell. There was swimming and ice-skating on the ponds. Interestingly, when Russell Avenue was paved in 1899, the stones were taken from the stone walls that ran along the farms and were crushed for the roadbed.

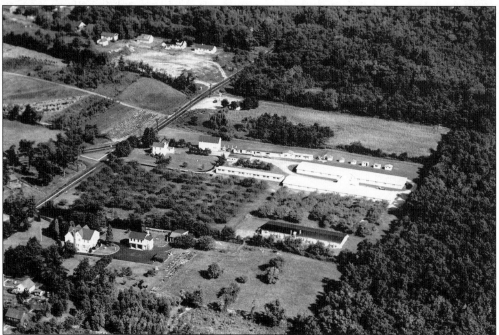

Peter Pulis had a nine-acre egg farm at the corner of Godwin and Brookside Avenues. At one time, the Pulises had the largest egg-production operation in New Jersey. In the lower left, note the house that was donated to the town by Ms. Larkin. It was restored by the town, which maintains it as a community meeting room used by many local organizations.

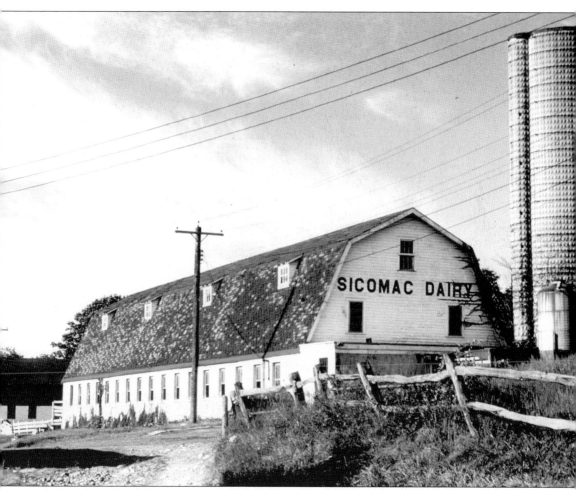

Lucas and Anna Galenkamp originally purchased Sicomac Dairy in 1918. Lucas was a baker in Clifton before starting the dairy farm. As the milk business developed, Sicomac Dairy delivered milk around the area and had milk vending machines around Wyckoff.

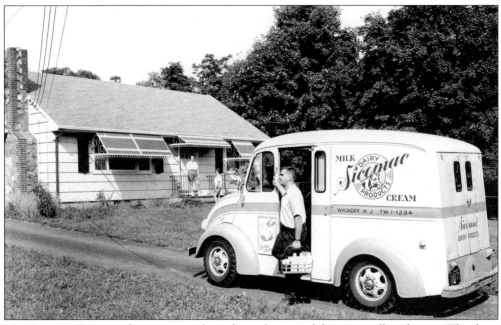

The Sicomac Dairy trucks were seen throughout the area, delivering milk to homes. The dairy also delivered eggs and butter.

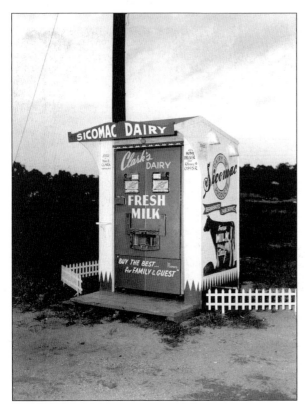

One of the innovations of the 1950s was the milk vending machine, which was used when home delivery was starting to be discontinued.

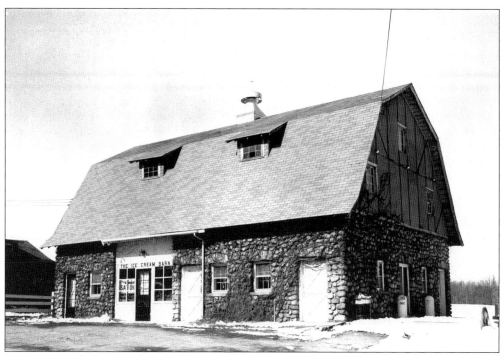

Known as the Luke Post farm building or the William D. Winters Homestead, the Ice Cream Barn was built c. 1900 as a cobblestone barn. It functioned as part of the Sicomac Dairy as an ice-cream stand. It is now used by the Faith Community Church.

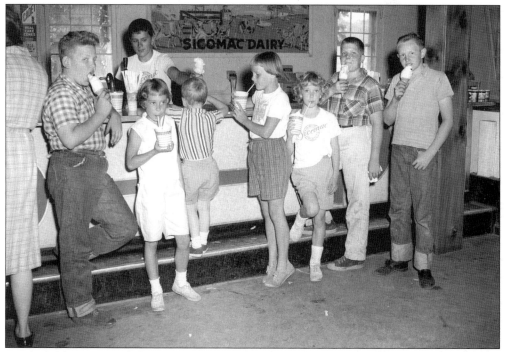

Local children enjoyed the Ice Cream Barn on Sicomac Avenue. People would drive from distances just to have some of the local ice cream.

James F. Welch bought a farm from the Terwilliger family *c.* 1890. The farmhouse was the only home on a large stretch of Godwin Avenue (then called Wyckoff Road). The main house was split, and the right part was moved closer to Godwin Avenue and became a funeral home. Welch's son Curtiss and a friend dammed up the river behind the barn to make a swimming hole.

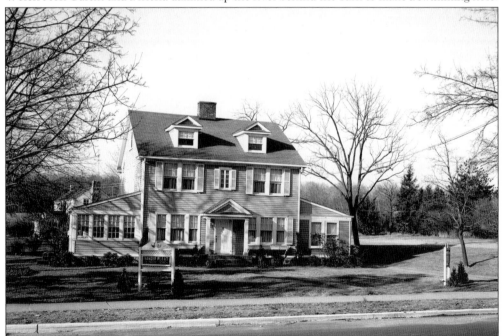

The old Terwilliger farmhouse was split in half, and one part was moved near Godwin Avenue. This house was expanded and became Vander Platt Funeral Home. The Vander Platts prepared Pres. Richard M. Nixon after he died in 1994.

Three
OLD STRUCTURES

Even though the Dutch were known for building stone houses, many other homes and barns were built out of plentiful wood. The very early structures were usually plain and functional. Since farming was so prevalent, almost all of the very old structures in town are farmhouses or barns. The buildings will continue to stand if maintained properly but are much more prone to damage by the elements. Homeowners and businesses have done their part in maintaining historic structures.

In the 1876 building survey, Franklin Township is listed as having 90 homes, some mills, 2 schools, 4 blacksmith shops, a church, a hotel, and several stores. The atlas described the village as "handsomely located for building purposes; its gravelly soil is requiring less ploughshares, its acres are transformed into villa plots, building lots, streets and avenues, along which several costly residences appear."

Fire was a constant threat to frame homes. In 1905, a fire on the Ewing estate destroyed 24 outbuildings. A fire department was started soon after. Over the years, fires have claimed several historic buildings. Many of the buildings pictured are listed in the Bergen County Historic Sites Survey, which periodically updates the county list of buildings with historic value.

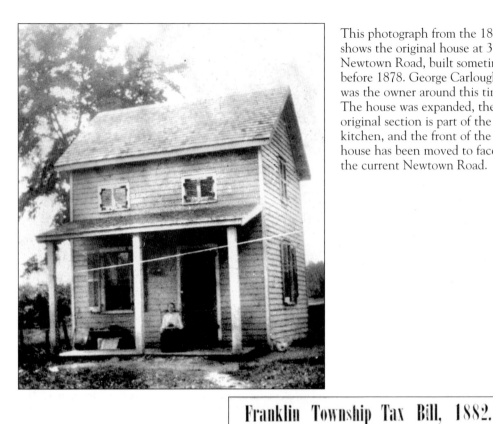

This photograph from the 1880s shows the original house at 318 Newtown Road, built sometime before 1878. George Carlough was the owner around this time. The house was expanded, the original section is part of the kitchen, and the front of the house has been moved to face the current Newtown Road.

This tax bill from 1882 for George Carlough's house on Newtown Road was signed by Peter Quackenbush, the tax collector. It informs the resident that the tax can be paid at Quakenbush's home any day but Sunday or at John Mowerson's store.

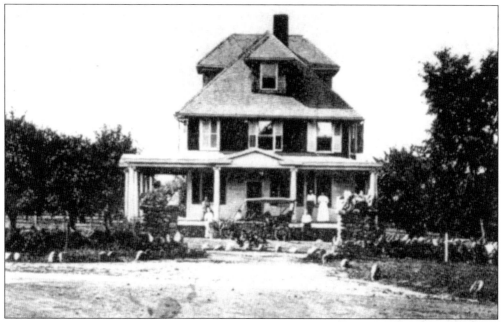

The original Wyckoff Hotel was built by John Ecker in 1779. During the late 1800s, it was a familiar landmark in town. John Ramsey owned it, so it was also referred to as the Ramsey Hotel. Many official functions were held here along with many social events. This photograph is said to be of the hotel, at Russell and Wyckoff Avenues, before the building burned down in 1909.

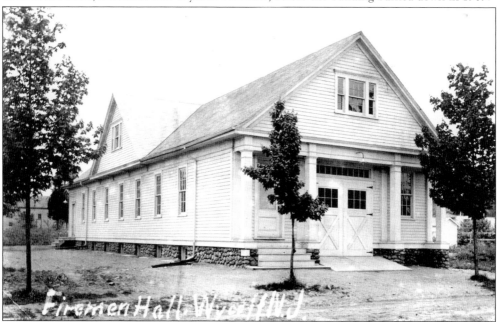

The first firehouse was completed in 1912 with a single truck bay using donations from the township residents at Clinton and Morse Avenues. Extensive renovations were done in 1925, and a siren was added to the building. The firehouse held township offices, and the fireman's hall was upstairs. The hall was used for many town and social functions. Ironically, the firehouse burned down in 1955 due to an electrical short.

35

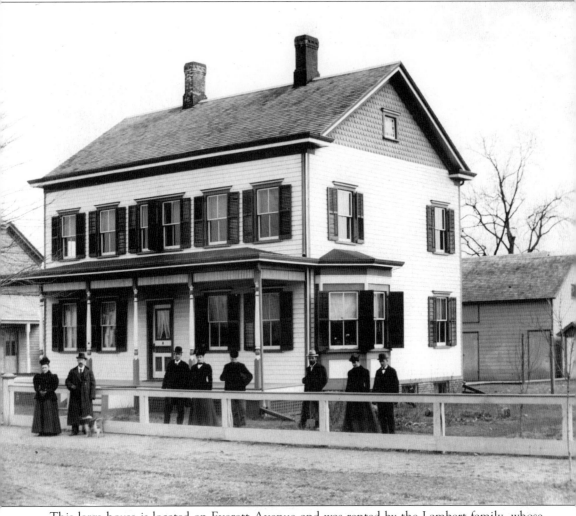

This large house is located on Everett Avenue and was rented by the Lambert family, whose grandfather built Lambert Castle in 1892. The photograph dates to the late 1890s or the early 1900s and is looking northeast. The gentleman standing third from the right is Daniel Depew. Note the typical house style for the era, although this is slightly more ornate than some. The house has undergone extensive remodeling, including the removal of the porch.

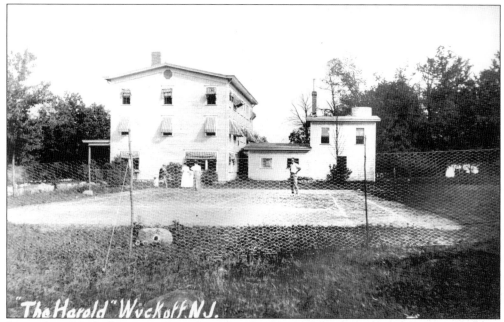

"The Harold" Wyckoff N.J.

Located on Wyckoff Avenue along the railroad tracks where the town hall now stands was the Harold House. After the railroad went through town, folks from the cities were attracted by the cool country air and boarded at the Harold House. The establishment was operated by Wilson and Phoebe Totten, and many a vacationer and traveling salesman would come to stay for a bit and for some home cooking. This is the view of the back of the boardinghouse as seen in 1912.

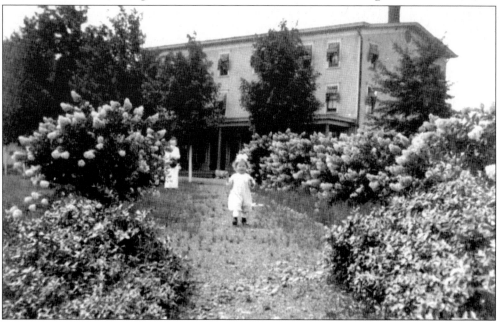

Flowering shrubs adorned the front of the Harold House. Pictured are Ella Totten Pederson and her son. Ella's grandparents were the Tottens, the owners of the Harold House. On school graduation day, schoolchildren would stop by and pick flowers to chain across the stage for graduation ceremonies.

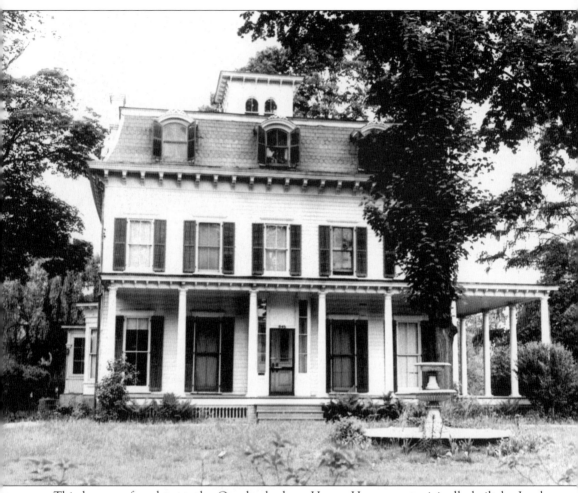

This house, referred to as the Quackenbush or Honey House, was originally built by Jacob Quackenbush *c*. 1870 and later sold to Frederick Hartung in the early 1900s. It became the residence of the Honey family *c*. 1939. The Honey family was a famous family acrobatic troupe that included six children. They performed in New York on Broadway and even for the king and queen of England. Honey House was torn down in 1955 to make way for the Wyckoff Shopping Center on Wyckoff Avenue.

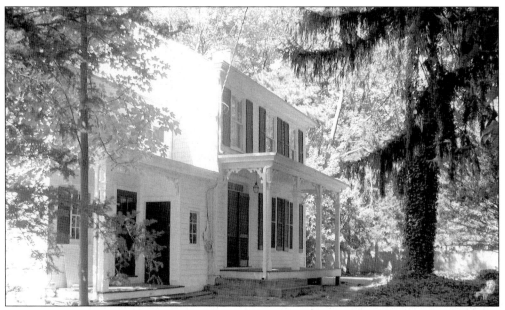

The charming Hopper House, as is it known, sits on the corner of Robin Place and Carlton, off Wyckoff Avenue. Henry J. Hopper and his wife, Catherine, lived here until they sold the house to the Hartungs in 1887. It was used to house various tenants and families until it was sold to Henry and Francis Smith, who renovated and restored the home. The large red barn is still on the property. The house faces Wyckoff and used to have a Wyckoff Avenue address.

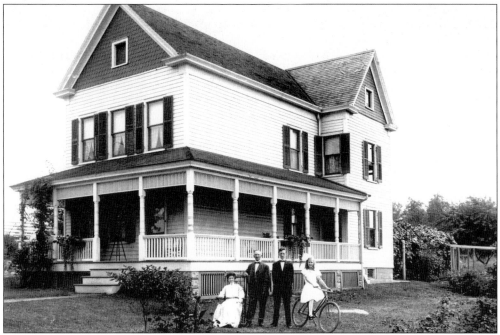

Charlie Parmley and his family resided in this house at the corner of Franklin and Madison Avenues. Parmley was one of the citizens who helped create the fire department and was the first assistant chief. The house has since been torn down, and a convenience store stands in its place.

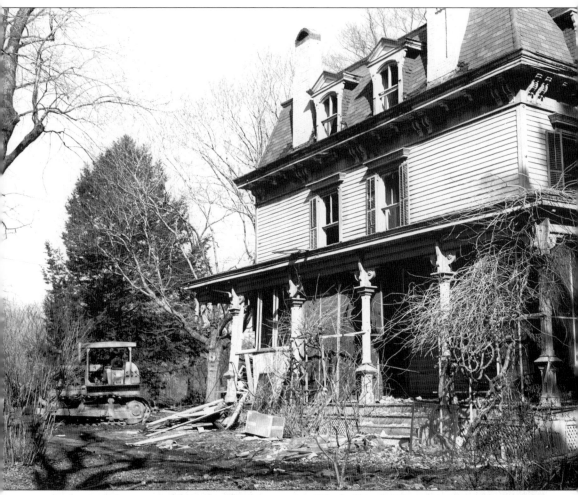

Catherine Hartung and her son Charles came to Wyckoff in 1875 and combined some land parcels to make a 225-acre estate. They built a 16-room Victorian house and several outbuildings at approximately 519 Wyckoff Avenue. Charles and his wife, Marie, had 11 children who grew up at the estate. A red barn from the estate still stands at the corner of Carlton Avenue and Robin Place. The Rockefeller Center Christmas tree in 1939 was taken from the Hartung property. The Hartung house is shown just before its demolition in 1966.

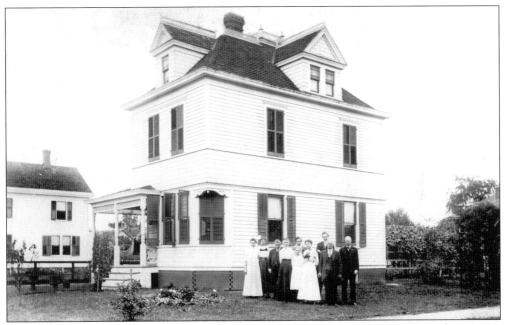

Seen here is the Winters family, including Myrtle Winters, George Winters, and James H. Winters. Their house still stands at Everett and Highland Avenues. James Winters (second from right) was the first fire chief of the Wyckoff Fire Department when it was formed in 1907.

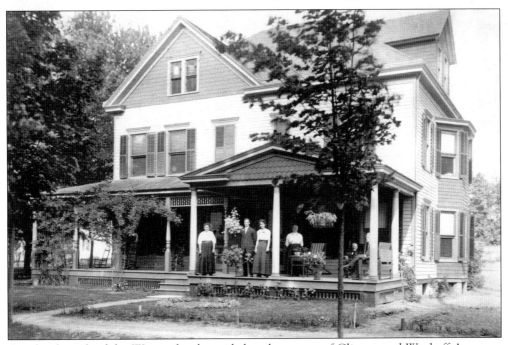

Another branch of the Winter family resided at the corner of Clinton and Wyckoff Avenues. This house is a charming example of a c. 1900 dwelling. It has been restored and has kept much the same appearance. It is now occupied by Lakeland Bank, at 652 Wyckoff Avenue.

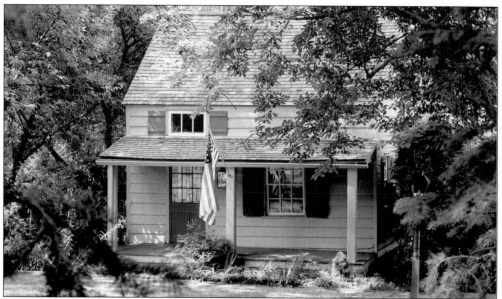

The Van Der Beck slave house resides on Sicomac Avenue. Its early history is unclear, but it is purported to have housed slaves in Closter in the late 1700s. It could also have been a farmworker tenant house. It came into the possession of the Van Der Beck family in 1846. A builder in Wyckoff, Walter Muller, with the blessing of the town of Closter, moved it to his property (the Van Houten–Ackerman House) in order to preserve the structure.

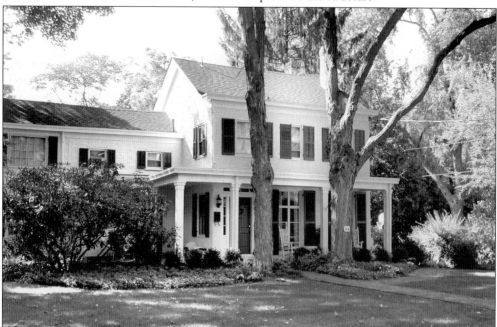

This house was built by Rev. Abram Ryerson c. 1849. Ryerson was the pastor of the Wyckoff Reformed Church from 1845 to 1865. He served as an army chaplain during the Civil War. The house has a beamed kitchen ceiling and large fireplace that was rebuilt out of bricks from an old Dutch oven. H.B. Frost was the owner of the home from the late 1800s to the early 1900s. The house can be seen at 515 Wyckoff Avenue.

42

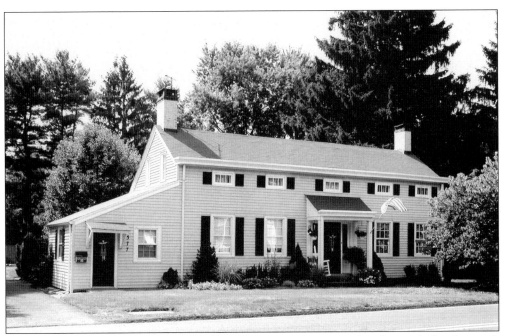

The C.A. Smith House, at 577 Wyckoff Avenue, is another example of an early farmhouse. It was built in the Federal style with Greek accents and one and a half stories with eyebrow windows. It dates from c. 1776.

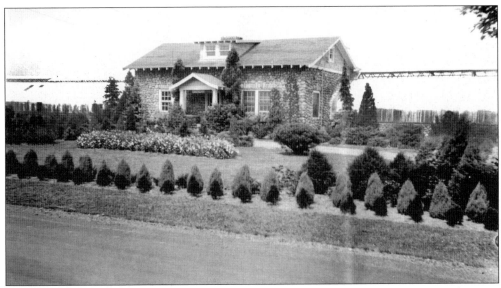

Established in 1898, the DeBaun Nursery (now Rousseau's) has been in town for more than 100 years. Alan DeBaun ran it for many years, and then Rodger Van Blarcom took over operation. Locals have patronized this business for as long as they can remember. Every winter, during holiday shopping, there is a warm fire burning in the wood stove inside.

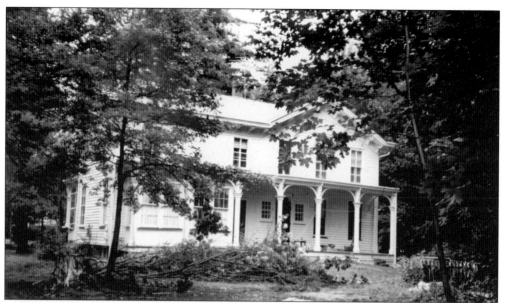

After serving in the Civil War, George Newkirk married Gitty Vreeland of Wyckoff. They built their home in an apple orchard near the Wyckoff Hotel in the 1860s. The George Newkirk House is a prime example of an Italianate-Victorian farmhouse that features oversized front and rear porches, symmetrical elongated windows, and original woodwork. Although it has been renovated several times, it remains close to its original design. In the early 1900s, it was occupied by a female dentist named Howe, who used the parlor to see patients. This is a view of the back of the house.

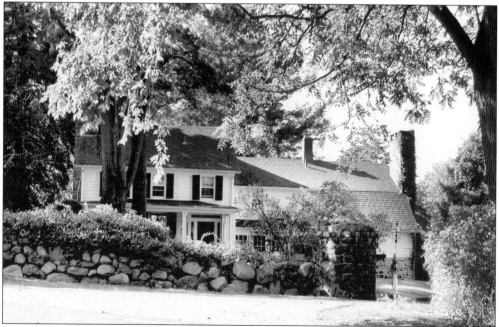

Jacob Blauvelt built this house in 1775, and it is located at 253 Brookside Avenue. The original property was about 500 acres. It was sold to Jacob Post c. the 1850s, and he is listed as the owner in the 1876 county survey.

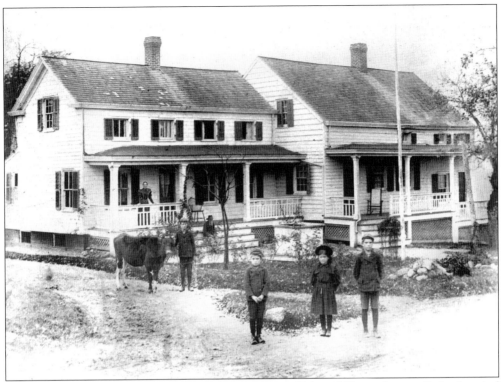

Built in 1779 on the site of an old mill, the Boget-Van Halstead House features Federal-period design with elements of Greek Revival–like eyebrow windows. It was also nicknamed Briar Patch Farm. Pictured in front of their house is the Mitchell family. The Brackett family bought the house and property in 1947, when it was in great disrepair, and made extensive repairs to it.

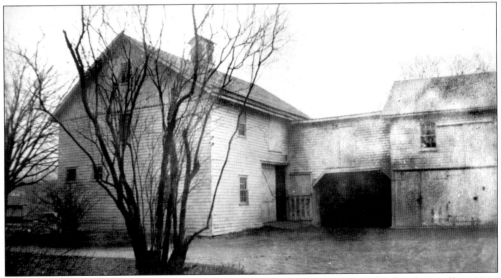

This barn functioned as the horse barn for Mowerson's grocery store. It had a close call in 1911 when some boys shot fireworks into the loft, but quick action by the fire department saved the barn. It was the home of several businesses, including a furniture and clothing store.

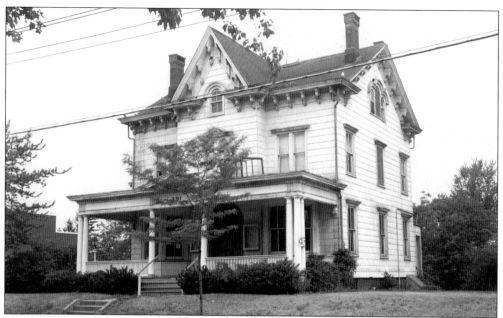

This Italiante-style house with Greek Revival gablets is one of the best-preserved examples of this style in the area. Situated at the corner of Clinton and Everett Avenues, it was built by Cornelius Vreeland in the 1870s. This was the home of Dr. Sherman Foote, the town health officer in 1933. The house was also occupied by Ralph Budd, an executive for Warner Brothers. The home was most recently a clothing store. The porch has been removed since this photograph was taken in 1964.

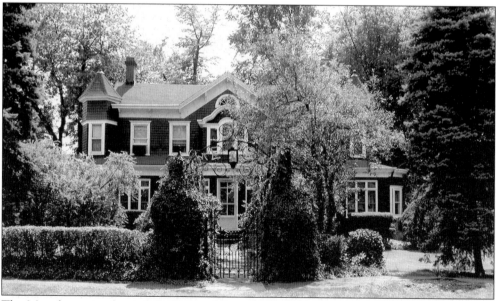

The Meer house is what is left of a much larger piece of land. A portion was donated to the town with the intent of building a new school, but it was not needed, and the town eventually used it to build Wyckoff Community Park. The original Italianate-style house was constructed c. 1850. It is historically known as the Stagg-Van Winkle House. It was converted to a mansion c. 1900.

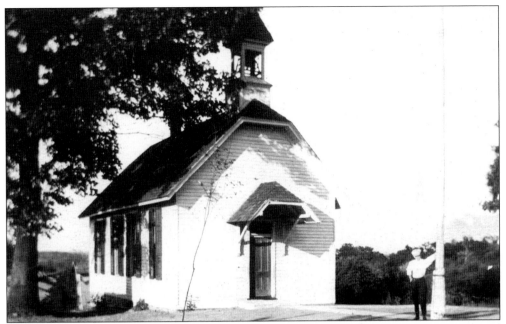

The Sicomac Schoolhouse was built to serve the students in the Sicomac area. As one entered the school, the boys' and girls' coatrooms were located just before the one-room classroom. It was heated by a coal stove. It was used until 1921, when it became the Sicomac Community Center. In 1938, it became the Wyckoff Fire Company No. 2.

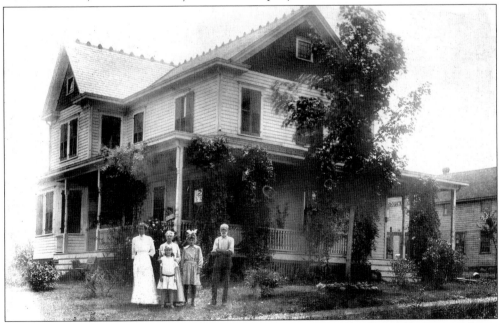

The Depew house was built on Franklin Avenue c. 1901. Pictured in this 1910 photograph are, from left to right, Charity, Elsie (as a child), Sarah, Florence (Elsie's sister), and Nathan Depew. Not shown is Elsie's father, Daniel Depew, who was fire chief from 1908 to 1911 and also ran a carpentry business. Elsie was born in this house in 1901 and lived here until she died at age 99.

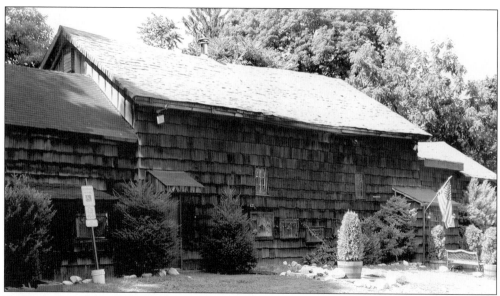

Built as a dairy barn in 1876, this building was turned into a restaurant by Matt Weinstein in 1929. Known as the Barn, it was originally a tearoom with live music and a dance floor. There were rumors that alcohol was served here during Prohibition, but they are not documented. After Prohibition, in 1934, the restaurant received the town's first liquor license. The Barn is hidden in the middle of a residential neighborhood, and there is no sign for it, so it can be hard to find.

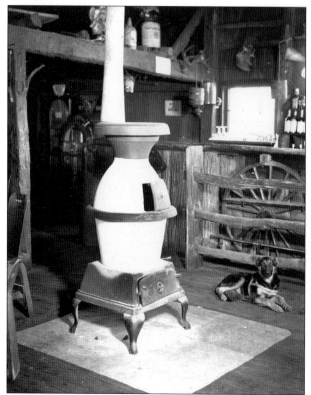

The property can be traced to the Zabriskie family. It was later owned by the Ackerman family and then by the Bates family. Taken in 1950, this photograph shows the interior and wood stove. The hand-cut beams attached by wooden pegs are still visible. The Barn is still currently operating as a restaurant.

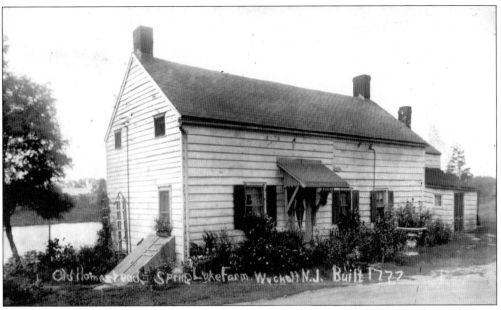

Known as the Old Pulis Homestead or Willis House, this home was built on the shore of Spring Lake in 1774. An addition was built in 1840. Peter S. Pulis purchased the surrounding property as well as the home in 1888. The Pulis family raised chickens and ran a farm adjacent to the lake. They also ran a sawmill at one end of the lake. Ice was cut from the lake in the winter, stored, and sold during the summer months.

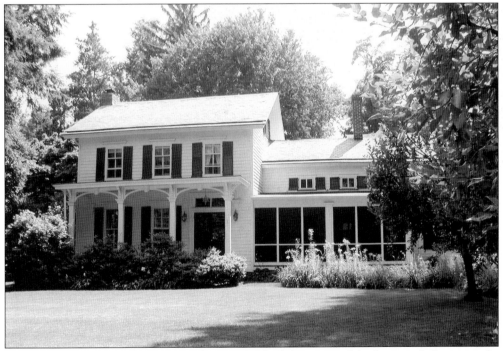

The C. Synder House was constructed in 1805. The left section of the house is Italianate style, and the original section on the right features a Downingesque style with eyebrow windows. It is situated on Sicomac Avenue, which is one of the oldest roads in Bergen County.

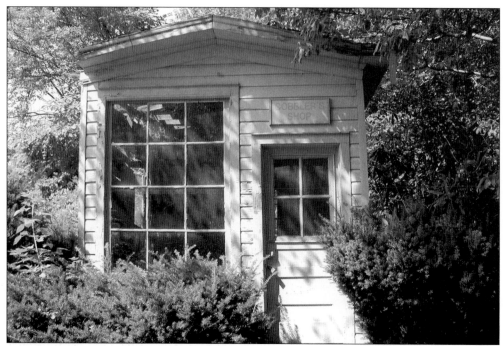

Known today as the Cobbler Shop, this structure was recorded as being a barbershop in 1905, when it was owned by John Lawrence. He worked for the railroad during the day and cut hair at night, using a kerosene lamp hung from the ceiling. The building was on Main Street and Everett Avenue before moving to its current home by Zabriskie Pond after being donated to the town by Sebastian Gaeta.

This structure is historically called the J.R. Terhune House. In this photograph, the sign reads, "The Old Brick House," and the brick exterior is painted white. The building has been a restaurant for many years. Today, the bricks have been stripped of paint, and extensive renovations have been made to the interior.

Four
COMMUNITY LIFE

Beginning in the 1900s, people came from New York City and Jersey City to get fresh country air in the then-rural Wyckoff. There were boardinghouses like the Stafford, Harold House, and Grove Villa (also known as "Aunt Sallie's"). Some of the early social activities were church picnics, baseball games on Zabriskie and Appert Fields, soapbox derby races down Clinton Avenue, swimming in several swimming holes in town, and Saturday night dances at the Grange. Block dances were held on Franklin Avenue, which was closed off for the events.

The fire department was one of the first community organizations formed. A fire in 1905 destroyed 24 outbuildings on the Ewing estate (now Franklin Lakes). Several residents decided that the town must have a fire department. Early founders were Charles Parmley, Daniel Depew, Valentine Goetz, James Winters, and the Reverend Strohauer. The time and dedication that the firefighters have put in over the years cannot be measured. There is a great sense of volunteerism in Wyckoff.

The police force was created in 1922. Prior to then, the police force consisted of several marshals appointed by the town and a constable appointed by the county. The first chiefs of police were Albert Holt, Thomas Young, James Morrison, and George Gallant.

Even though Wyckoff grew slowly in the early years, the post–World War II period demonstrated growth that added many nicely designed housing developments and single-family homes that seem to have filled in every open area. The town today is a mature suburban area.

The town has always had many sources of recreation. Old Home Week was an early town fair. The Memorial Day parade is an important townwide event that is held every year. Spring Lake and the YMCA continue to be a source of activity for the town.

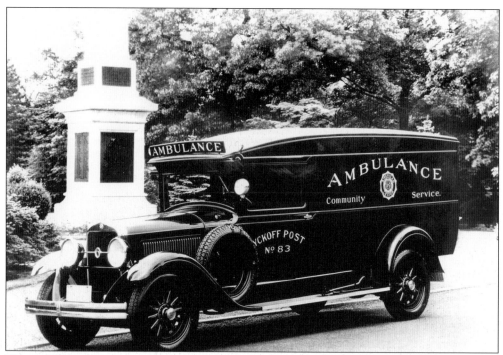

The ambulance corps was founded in 1929 by the American Legion post. Wyckoff had one of the first ambulance corps in the state. It was also one of the first to have a woman commander, Mrs. Ralph W. Budd, who had served as a nurse in World War I. This particular ambulance was sent to France in World War II to aid in the war effort, but a German U-boat torpedoed the freighter carrying it.

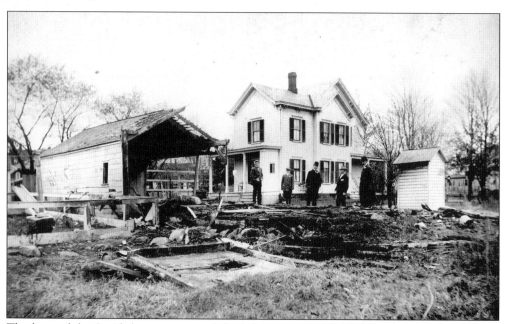

The barn of the Smith house was struck by lightning in 1910. The Smith house was located across from the railroad depot. The fire department was able to extinguish the barn fire.

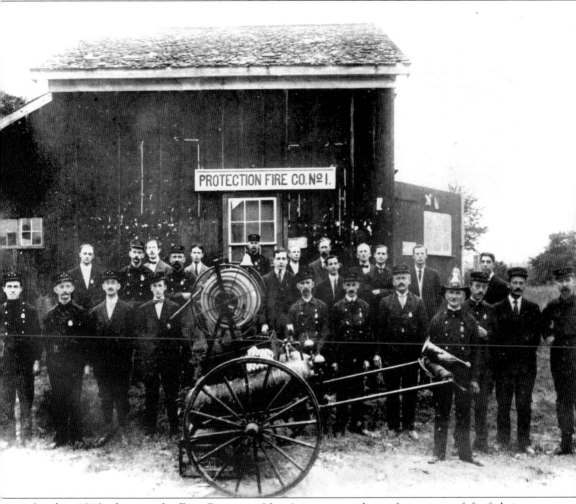

In this 1910 photograph, Fire Company No. 1 is seen with its first piece of firefighting equipment, a two-wheeled chemical unit purchased for $150 that came from fundraising events. The equipment was kept in Charles Hartung's barn. Pictured, from left to right, are the following: (front row) A.J. Laurence, Charles Vanderhoff, H.C. Harned, Harold Parmley, William Winters, Bruce Scott, Valentine Goetz, Charles Parmley, two unidentified men, and ? Porter; (back row) William Scott, Adrain Westveer, Joseph Ruddick, Daniel Depew, Joseph Duthie, John Lawrence, two unidentified men, Peter Van Houten, Herman Klomburg, Walter Wright, and three unidentified men.

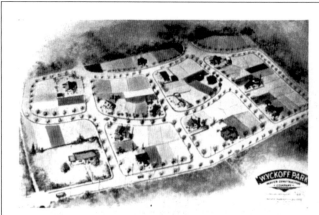

This advertisement from 1923 is one of several plans to develop Wyckoff housing. The most famous was the acquisition of the triangle of land bounded by Main Street, Wyckoff Avenue, and Franklin Avenue by real estate developer Cornelius Vreeland in 1870, after the railroad reached town. He laid out streets and building lots, but only a few homes were built, including his own on Clinton Avenue.

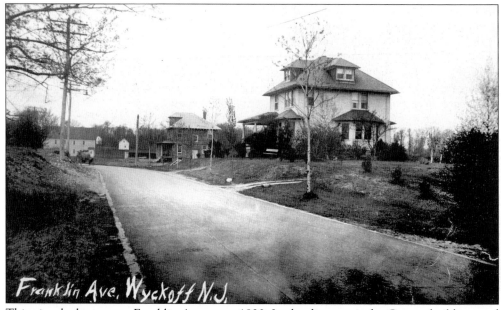

This view looks west on Franklin Avenue c. 1920. In the distance is the Grange building, and the Gallant family house is on the right.

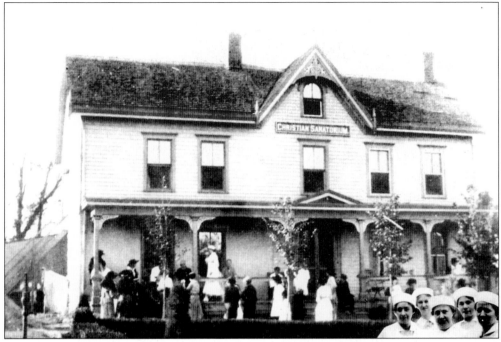

The Christian Health Care Center (CHCC) was founded in 1911 by a group of deacons from local Reformed and Christian Reformed churches. They wanted to provide physical, mental, and spiritual care, regardless of affiliation, for mentally ill patients who would otherwise be uncared for. Funds were raised, property was purchased, and the farmhouse renovated, and in 1917, the Christian sanatorium opened. Through various expansions, the CHCC provides a wide range of care to the community today.

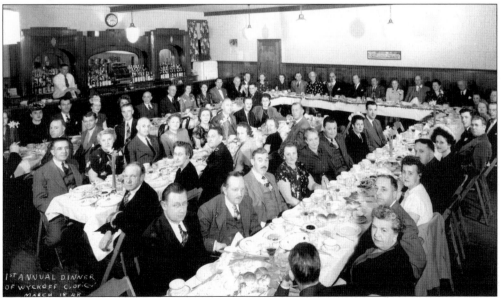

The Wyckoff Chamber of Commerce was started in 1947 with George Gallant as president. Most of the early businesses are represented in this picture of the first annual dinner in 1948. Sam Braen was elected president in 1948.

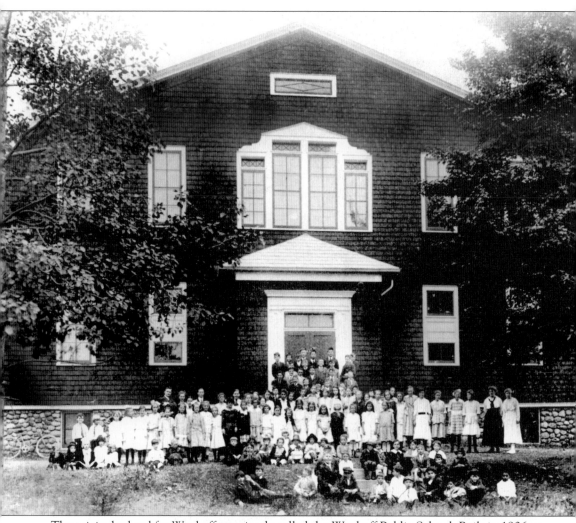

The original school for Wyckoff was simply called the Wyckoff Public School. Built in 1906 on land deeded to the town by John Hopper, it took the place of two one-room school buildings. It functioned as a four-room school (two up and two down) for the fifth through eighth grades. A fire broke out during Christmas break in 1921, and the building was destroyed despite the efforts of local firemen. The George Washington School was built on the site.

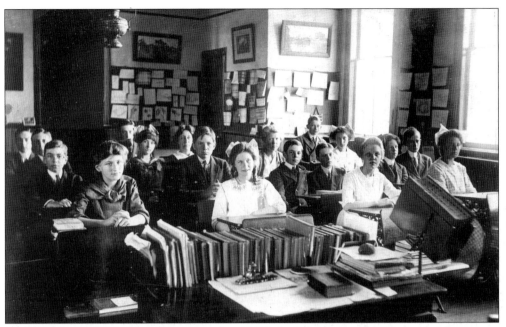

Seen here is a *c.* 1910 class picture from the old Wyckoff Public School. There were four rooms at the school, and each housed a different grade. Bernard Gallant Sr. is the second student from the right.

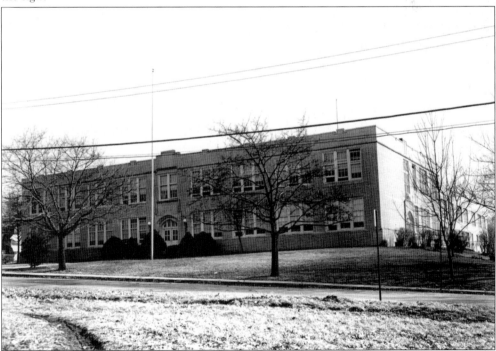

The George Washington School was built on the site of the old Wyckoff Public School. Students used the firehouse and Wyckoff Reformed Church until the new school was completed in 1922. The school contained 11 classrooms and was built at a cost of $100,000. An addition in 1957 added 11 more classrooms.

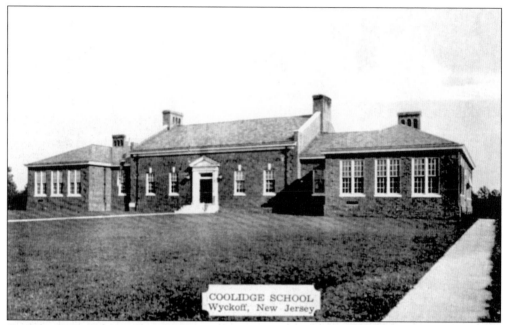

Coolidge School, located on Grandview Avenue, was built in 1932 for $80,000 to serve the students from East Wyckoff. There were originally six classrooms, but additions in 1948 and 1958 added 10 more.

The Abraham Lincoln School was built in 1953 on a 20-acre parcel. It contained 10 regular classrooms, a gymnasium, and an auditorium.

On Sicomac Avenue, the Sicomac elementary school was completed in 1967 with 20 classrooms. The school is built on part of the 40-acre Daniel Terhune farm, which began operation in 1895.

The schools conducted air-raid drills against the backdrop of the cold war. These students from the Abraham Lincoln School crouch in the hall after hearing the town sirens in 1954. They are being watched over by their teachers.

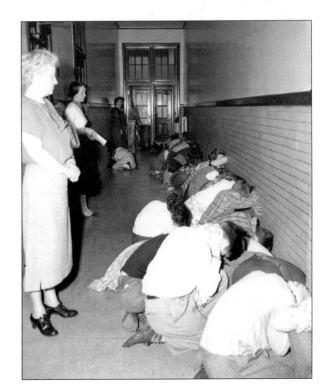

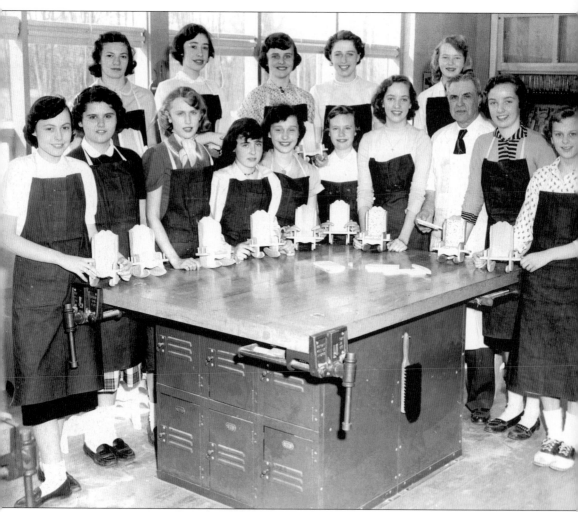

Seen here is the Arts and Crafts Club from the Abraham Lincoln School in 1957. From left to right are the following: (front row) Marilyn Kauflin, Cecilia Faucett, Joan Jordan, Judith Benninger, Ellen Benvenuti, Marcia Touw, Elizabeth Orthouse, ? Gray (instructor), Geraldine Orthouse, and Susan Simonds; (back row) Susan McMann, Caryl Clundt, Gail Mather, Lynda Ippolito, and Susan Murray.

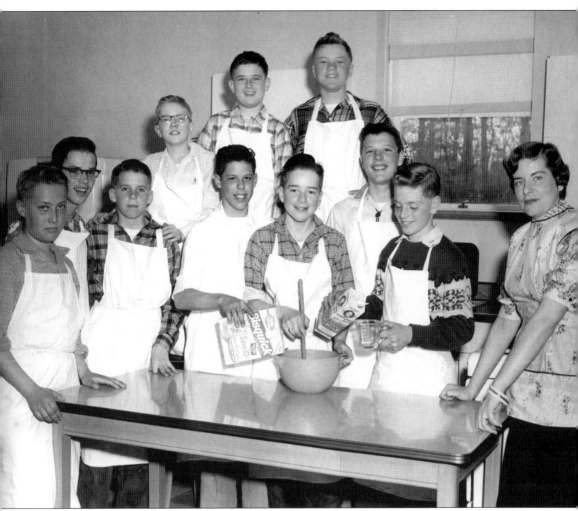

Members of the Chef's Club at the Abraham Lincoln School pose in 1957. From left to right are the following: (front row) Gary Kientzler, Douglas MacGregor, Harry Thurber, Donald Warren, Frederick Nielsen, Albert Ross, Robert Pruiksma, and ? Madison; (back row) Eric Johnson, John Stevens, and Norman Taranto.

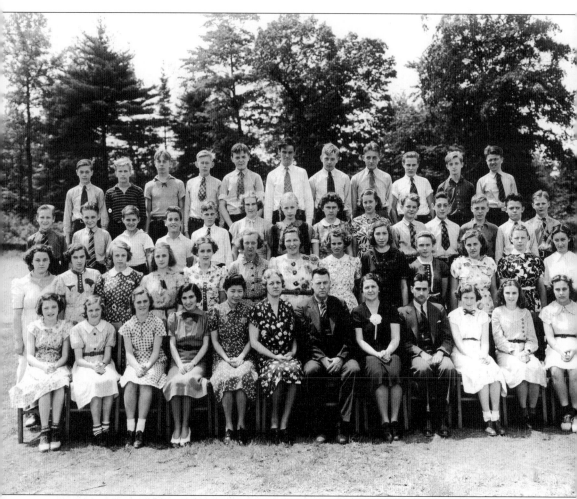

The members of the George Washington School Class of 1938 are, from left to right, as follows: (first row) Lillian Myer, Mildre Outslay, Jean Earley, Angela La Greca Gionti, Eileen Tam, Marian Mickens, Harry Mason Jones, Lillian Coda Knott, Stephen Gerace, Lucille Gamerton, Marilyn Eastwood, and Gertrude Erhardt; (second row) Henrietta Koetsier, Edna Chreur, Elsie Van Kampen, Margaret Sterling, Marion Gee, Elfrieda Lunsmann, Eleanor Felix, Elizabeth Adma, Norma Noblet, Valerie Was, Dorothy Woodbury, Irene Lentz, and Myra Berry; (third row) Robert Murray, Charles Gamberton, Richard Kook, John MacGgregor Jr., Russell Blum, Virginia Colling, Grace Schaper, Margery Packer, Jean Marble, Philip Hoffman, Roland Van Syckel, Robert Schlenz, William Mills, and William Van Genderen; (fourth row) John Kuiken, James Ward, John Yoemans, Edward Lewis, Harvey Burke, Robert Grant, Jacob Van Kampen, Norbert Smith, Eugene Yost, Franklin Bosch, and John Grace.

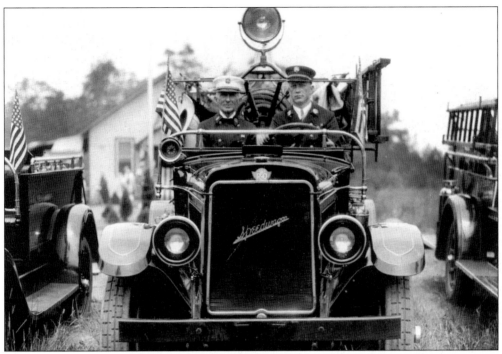

Charles Parmley (left) and Lester Van Houten are seen in a Speedwagon from the 1930s at a show of fire engines. They were both chiefs of the Wyckoff Fire Department over the years.

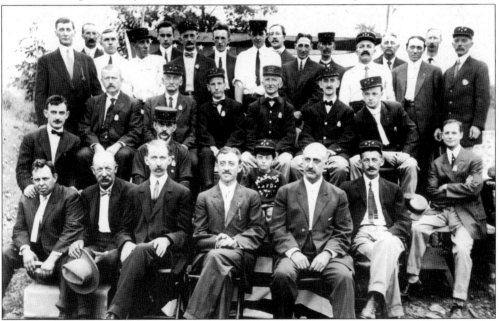

The Wyckoff Volunteer Fire Department is shown in 1915. Some of the members in the photograph are George Hubbard, William Kretzler, Walter S. Wright (child mascot), Adrian Westveer, Ed Cook, J. Van Kurfal, Archer Mowerson, James Winters, John MacGregor, Charles and Harold Parmely, Harry Harned, William E. and William C. Scott, Irving Winters, Walter F. Wright, Joseph Ruddick, and James Morrison.

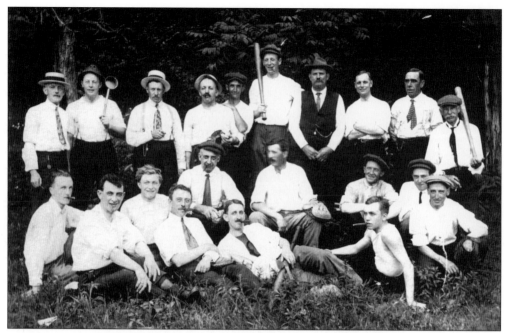

Seen here is the Wyckoff Fire Department softball team from 1912. The team played against other fire departments in the area.

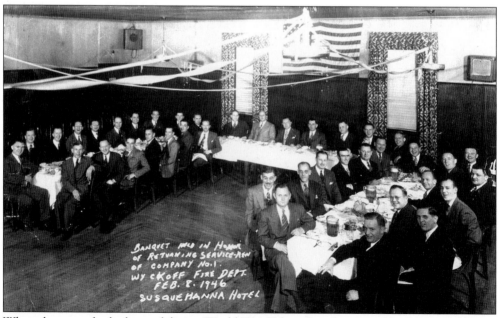

When the men who had served during World War II from Fire Company No. 1 returned home, a banquet was thrown in their honor at the Susquehanna Hotel.

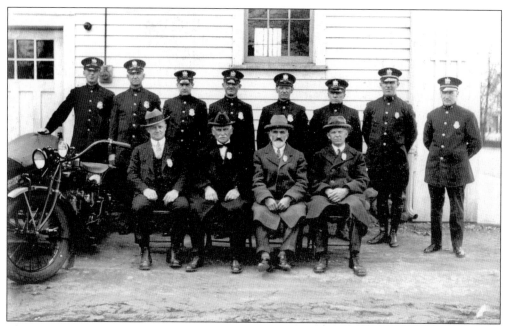

The police force in Wyckoff is pictured with a motorcycle *c.* 1927. Before the force was created in 1922, law enforcement consisted of several marshals and a county constable whose main function was traffic control at the intersection of Wyckoff and Franklin Avenues. Sitting in the front row are, from left to right, William Scott, Judge Ward, William MacDonald, and an unidentified man.

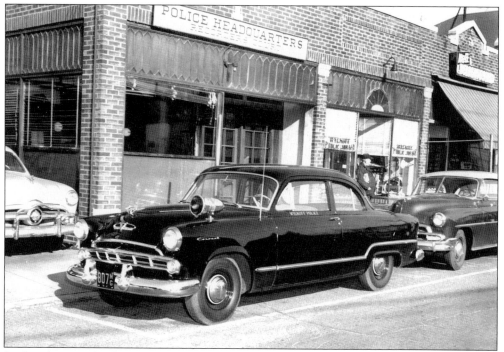

In this photograph, the police department's new cruiser is parked in front of the police station in the Sterling Building.

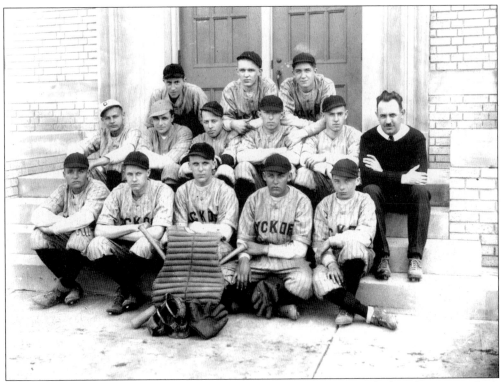

The Wyckoff Athletic Club baseball team poses in 1928. The town had no leagues, so boys joined the athletic clubs.

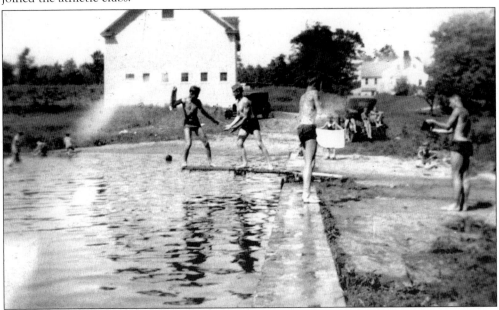

One of the local swimming holes around town was known as Welch's Pond. When Curtiss Welch was 14 (c. 1927), he and his brother dammed up the stream by their house to make a swimming hole. Seen here are some friends who came by to swim. The Welch barn is in the background, and their house, the old Terwilliger house, is on the right.

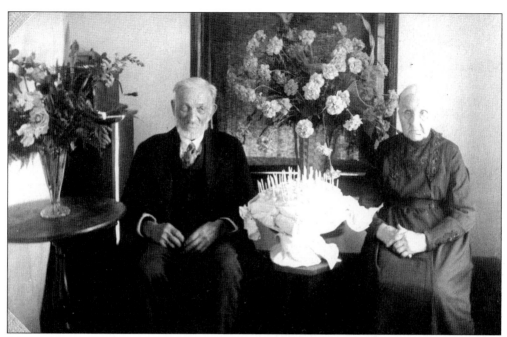

John and Susan Demarest celebrated their 75th wedding anniversary in 1925. It was considered a town holiday for them, and schools and businesses closed at noon. President Coolidge sent congratulations to the couple. John Demarest was born in Wyckoff in 1828, and Susan Winter Demarest was born in 1832. They both passed away in 1927.

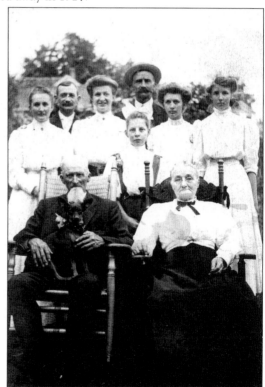

The members of the Winters family seen here are, from left to right, as follows: (front row) William P. Winters, a Civil War veteran who served in the 22nd New Jersey Regiment; Beauty, the family dog; and Martha Cummings Winters; (back row) Mame More; Will More; Jesse More; Ed Winters; Maude Winters Hull; Grace More Walter; and Myrtle Winters Scott.

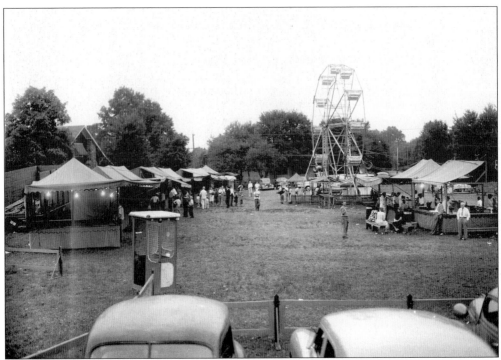

Wyckoff had an annual town fair called Old Home Week, sponsored by the American Legion post and held during the summer starting in 1939. These were held on Zabriskie Field at the corner of Franklin and Highland Avenues.

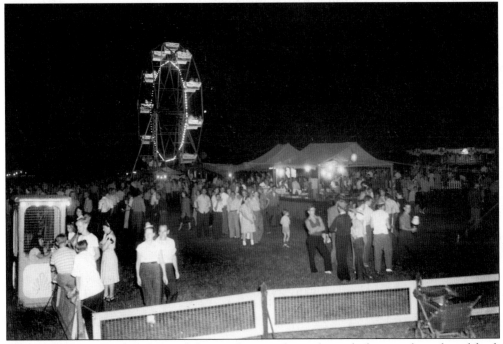

There were carnival rides, games of chance, dancing, fireworks, and of course, lots of good food. These events were eagerly anticipated and always well attended by area families and youths.

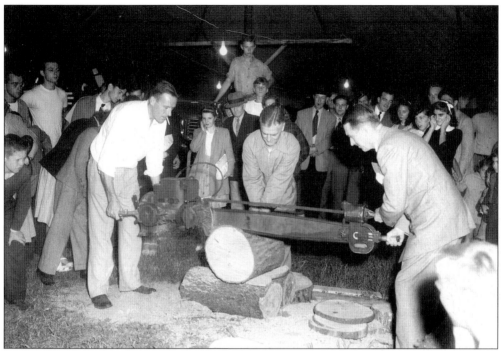

Rodger VanBlarcom (left) and Ed Harned (right) demonstrate a chain saw during Old Home Week in 1949.

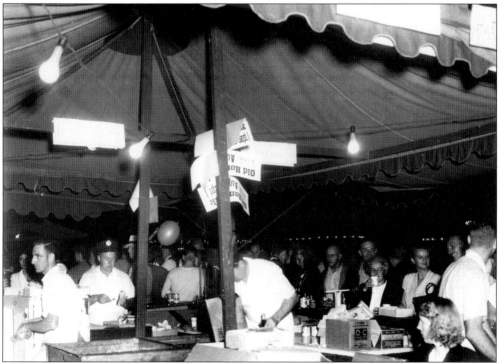

Fair attendees gather under a tent to sample some of the different foods offered. The local fire department helped staff the concessions and food stands.

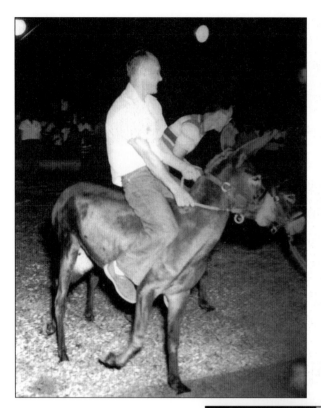

One of the pastimes in the late 1930s was a game called "burro ball," which was a form of baseball but with the bases run on a donkey. It was played by the town firemen on various fields, including Zabriskie Field, and apparently there were night games.

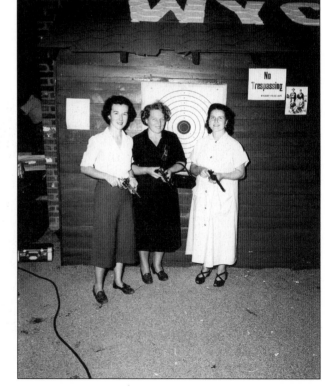

Florence Hood (right) is seen at a sharpshooting contest. She was renowned in the area for her marksmanship. The event was held at the Wyckoff Rifle Range on West Main Street. Pistol tournaments drew participants from many states.

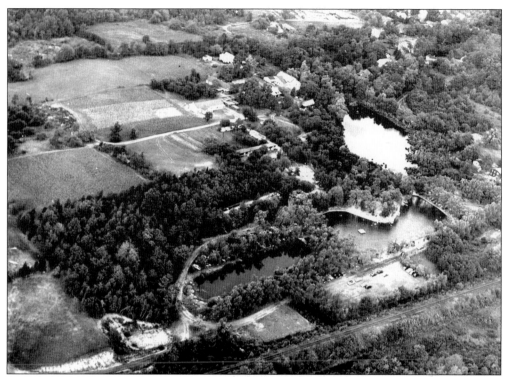

Peter Pulis donated 19 acres of land, including Spring Lake Park, which was run by the Pulises. Spring Lake Park is the middle lake in this photograph.

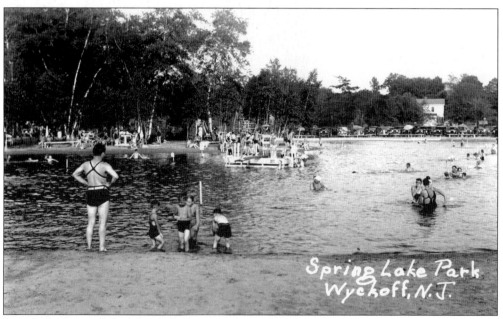

Peter Pulis donated the lake to the town as part of the Spring Meadows Condominiums project. The town bought some additional acreage and, beginning in 1944, leased the entire property to the YMCA.

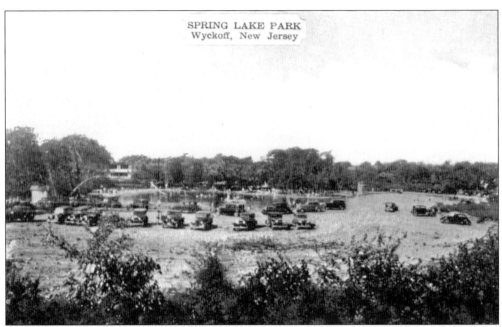

A 1930s postcard shows Spring Lake Park as an attraction to be visited in Wyckoff. Plenty of parking was available. This is now the YMCA.

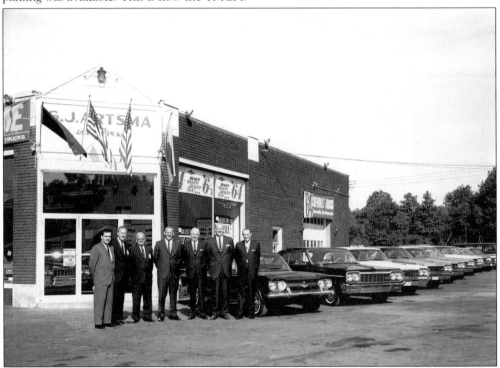

The Wyckoff Elite Garage, at the corner of Godwin and Franklin, was owned by Albert Muys in 1929. A resident recounts that during 1942, a few cars had to stay wrapped in brown paper, unsold, in case of war emergency. The Artmsa dealership moved here from Midland Park in 1954 and was a fixture in the town for many years until it was razed for a shopping mall.

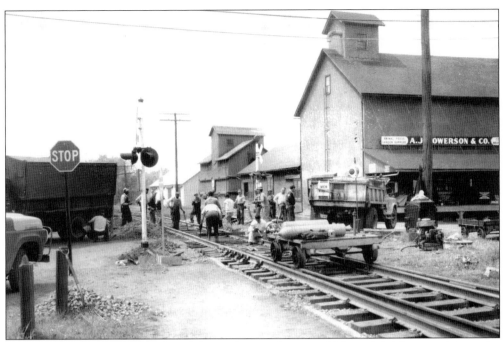

Seen here is a view of railroad work being done with manual labor. A.J. Mowerson's is in the background. The storage sheds held feed, coal, and masonry materials. They received their materials mostly from the railroad and had their own train car siding.

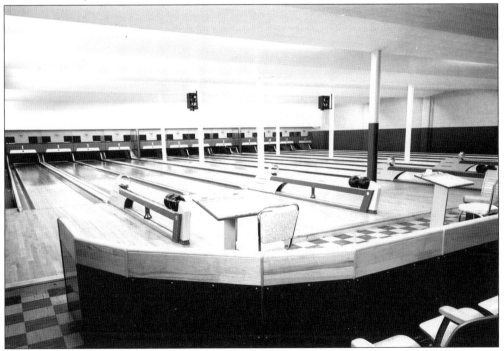

Wyckoff Lanes was located in the Donnelly Building on Franklin Avenue. Bowling was very popular, and the Wyckoff teams competed for local trophies. The building now houses a gym and the Sock Factory.

The following Officers were Elected

at the Anual town meeting Mar 10 1891

Justice of the peace	John Ackerman	D
Chosen Freeholder	David H. Spear	D
Township Clerk	Robert V. Lewis	D
Assessor	John W Ackerman	D
Collector	Peter Quackenbush	D
Commissioners of Appeals	A. B. Depew	D
	Henry McNomee	D
	Abram J. Past	D
Township Committee	Peter S. Winters	D
for Constable	Peter S. Herring	Dem
Overseer of Poor	Jno W Packer	D
Surveyor of Highways	William Shuart	D
	Lewis S Van Blarcom	D
Pound Keeper	Joel B Brokaw	D
	Peter Quacken bush	D
	David C Bush	D

Resolved. the bounty
on fox 2.00 muk 100. weasel 25c $ 2.500 for
road purposes 30000. for township
purposes.

Robert V Lewis
township Clerk

Seen here are the official results from Franklin Township's elections in 1891. Besides some of the established family names, such as Quackenbush, Depew, Ackerman, Winters, and Van Blarcom, there is a note at the bottom offering bounties of $2 for a fox and 25¢ for a weasel.

Judge John Zabriskie had the stream in front of his house dredged to make a pond. Grace Marion Zabriskie donated the pond and five surrounding acres to the town in 1963. Today, the pond is the site of an annual fishing derby.

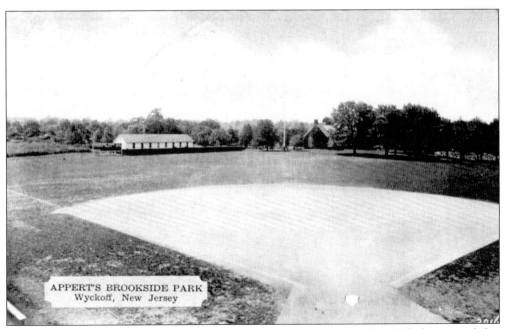

APPERT'S BROOKSIDE PARK
Wyckoff, New Jersey

Appert Field was at the corner of Crescent and Brookside. Amateur baseball players used this field on the property of E.P. Appert. Appert was a local farmer who set up bleachers for the fans who showed up on weekends. An official scoreboard kept track of the hits and runs.

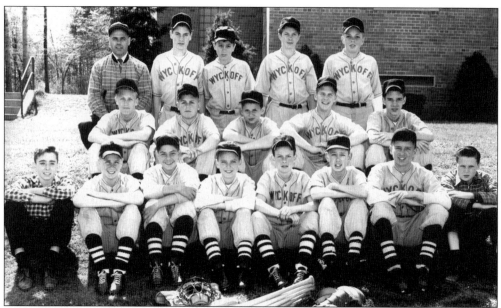

Seen in this photograph of the 1958 Abraham Lincoln School boys' baseball team are, from left to right, the following: (front row) Arthur White, Russell Tanis, William Wade, Charles Bonin, Charles Reber, Edgar Sewell, Kenneth Juall, and Robert Murphy; (middle row) Kermit McCormack, Anthony DeMarco, Douglas Ross, Edmund Carr, and Steven Decker; (back row) ? Nazzari (coach), Ralph Lafler, Gerritt Dross, Richard Van Duren, and Michael Walsh.

Seen in this photograph are, from left to right, the following: (front row) Carol Wraith, Carol Stetler, Barbara Jans, Robin Gaul, Gail Donohue, Jeanette Marcalus, Melissa Gray, and Mary Ellen Tobey; (middle row) Judy Ippolito, Olivia Rodgers, Gay Lengyel, Kathleen Orr, Coralie Coudert, Elizabeth Longden, Elaine Kauflin, Sherra Perna, and Nan Loucks; (back row) ? Nazzari (coach), Mary Jo Hoenig, Carol David, Linda Woodbury, Linda Levandosky, Jill Jacobson, and Sharon Smith.

Seen here is the ribbon-cutting ceremony for the opening of the W.T. Grant store in 1958 in the Wyckoff Municipal Shopping Center, now known as Boulder Run. When the store opened in Wyckoff, it was a big event. This is before most large malls were built on the highways.

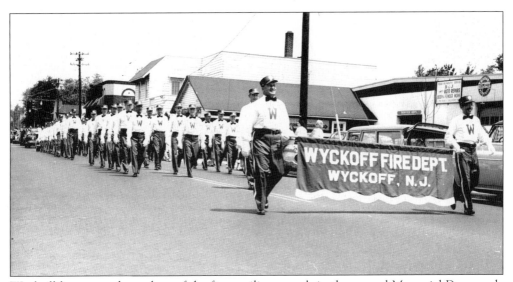

Wyckoff firemen and members of the fire auxiliary march in the annual Memorial Day parade in 1959. The Ladies Auxiliary has been active in the fire department for many years. The first parade was in 1919 and was sponsored by the American Legion post. In later years, the fire department sponsored fireworks on Labor Day.

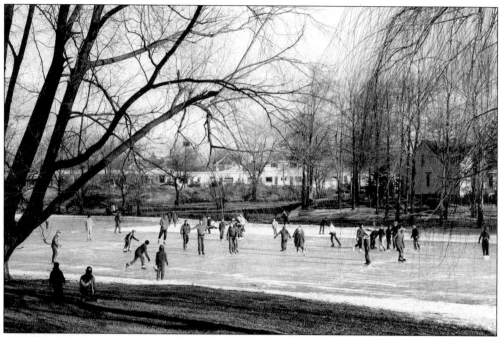

Children skate on Zabriskie Pond in 1955. When the weather got cold, the ice on the pond would bring out the townsfolk. Mrs. Gallant, who lived next to the pond, would bring out hot chocolate to the skaters.

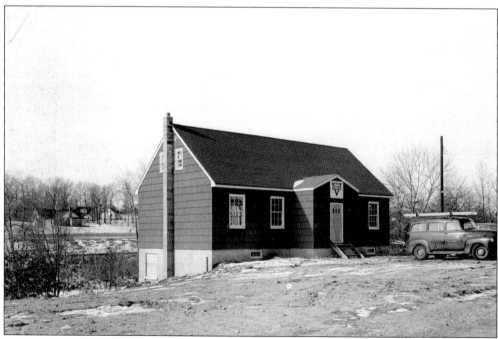

The YMCA of Wyckoff was started in 1944. The first home of the YMCA was on Ward Street, where land was sold to the organization at a low cost by the Welch family. The building was constructed entirely by volunteers. A swimming pond was dug behind the building and lined with sand.

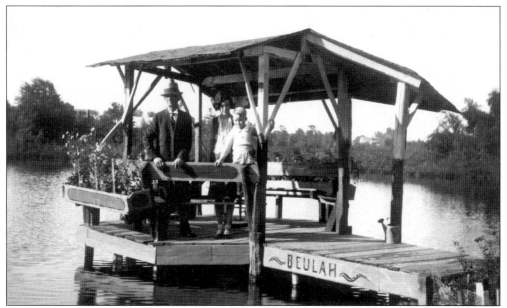

A pier juts into Pulis Pond before it was developed. Seen here are Bernard Gallant Sr., Helen Gallant, and Bernard Gallant Jr.

When the board of education decided that they no longer needed the property that was donated by the Meer family, they decided that a community park would benefit the town. Financed entirely though donations, the park was completed in the 1990s. It features ball fields, pathways, a scenic bridge, and a recreation center.

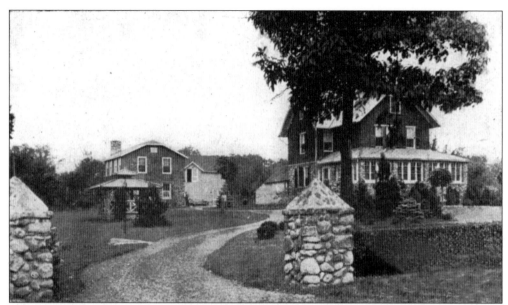

This is a 1923 picture of Opici Villa, which was along Wyckoff Avenue. There was another Opici on the same road, and there is some disagreement over whether this site is the same one that was later called Larkin House. The Larkin House was bequeathed to the town when Mrs. Larkin passed away. It has been completely renovated and is used by the town as a community center.

What is now Route 208 was an old path to the Oakland area. It was formerly known as the Arcola-Oakland Highway S-4. It was the center of controversy for many years. The rough grading was done as a Works Progress Administration project in 1930. Since the road divided the town in half, a demand was made to the state that many overpasses would be built. The road was partially completed in 1949 and finished in 1959.

Pictured, from left to right, are Irma Cordes, Barbara Hazen, Robert May, and an unidentified person in the Station Sweet Shop, which was in the Lawlins Building on Main Street across from the railroad station. The owner's name was Pruden, and the shop was later sold to a proprietor named Clem. This was a popular spot for children to stop at after school.

Al Cerra's barbershop is seen as it appeared in 1950. Still a popular place to get a haircut, the barbershop was a mainstay of Main Street. Tony (left) and Al are ready for customers.

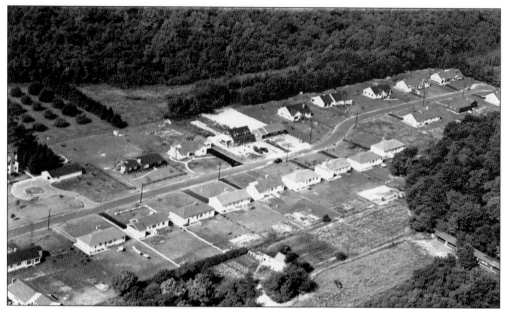

This development is one of several that were common during the late 1940s and 1950s. Some of the local development names were Grandview Heights, Stagg Brook Estates, Allison Acres, Artistic Acres, Old Hartung Estates, Old Woods Acres, Old Brookside Acres, and Crescent Gardens.

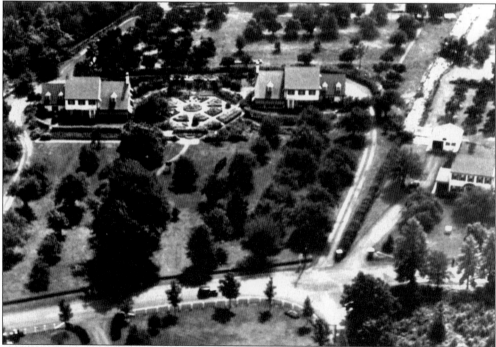

This 1930s photograph shows what are known as the "twin houses" on Sicomac Avenue across from Russell Farms. These two houses were built in the 1930s by Grace Russell for her two nieces as summer homes. The houses are mirror images of each other with a shared garden. One niece married a Winan, and the other married a Fairhurst.

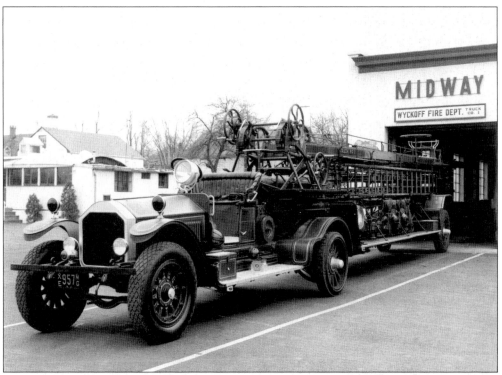

The fire department purchased its first hook and ladder in 1945. Shown is a 1923 American La France that was stored in the Midway garage until a permanent home was secured.

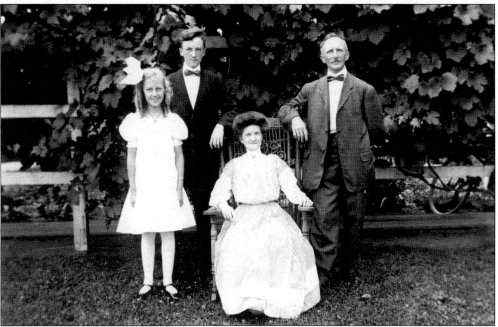

Charles Parmley (right) was an import figure in the community. He was fire chief of Wyckoff from 1911 to 1913, 1916 to 1920, and 1923 to 1937. This photograph shows him with his wife (seated), Lial, and Harold.

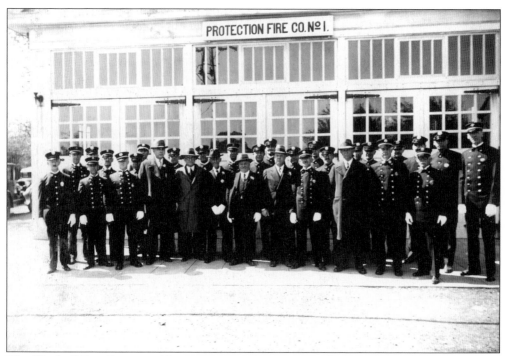

The Wyckoff Fire Company No. 1 is seen in this *c.* 1930 photograph. Note the three large double doors for the fire trucks. As soon as the alarm sounded, men would run out and open the doors for the trucks.

Members of the fire department band entertain patients at a nursing home. The fire department had the first band, and later there was the municipal band.

Old-timers night at the firehouse is seen in this photograph, taken in the mid-1960s. From left to right are Burrit Lawlin, Robert Mowerson, Fred Seitz, Les Van Huten, Sam Dorhout, Arthur Lawrence, Charles S. Pulis, Charles Lentz, Harold Quackenbush, and Herbie Mitchell.

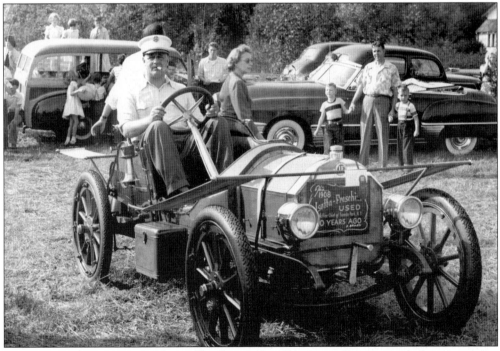

Sam Braen is shown in a 1910 Isotta-Fraschini Italian luxury car. Braen owned a large quarrying business and was fire chief from 1947 to 1957. At one time, the area where the A & P shopping center is now was an oil company that Braen bought from Sam Dorhout.

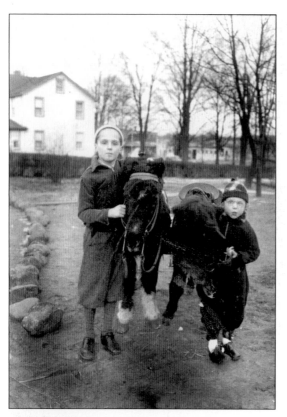

Margaret Jane and William Budd ride their ponies by Clinton Avenue in downtown Wyckoff. It was not unusual to see people on horseback around town up to the 1930s.

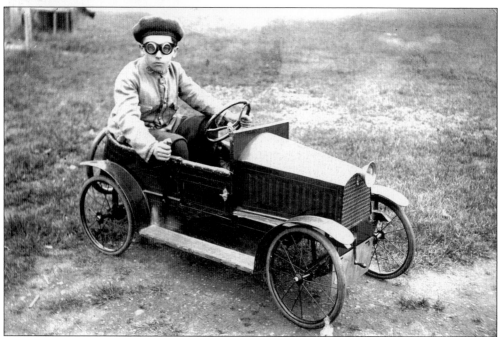

Walter S. Wright, seen taking his truck out for a drive, was the mascot for the fire department when he was younger and became a fireman when he grew up.

A young woman waits on the dirt road next to the old Sicomac Schoolhouse. This was a one-room school to teach the children in the Sicomac area.

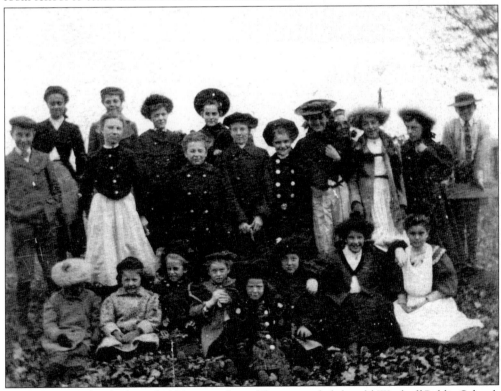

The grammar school Class of 1908 is seen here. They attended the old Wyckoff Public School, where George Washington School now stands.

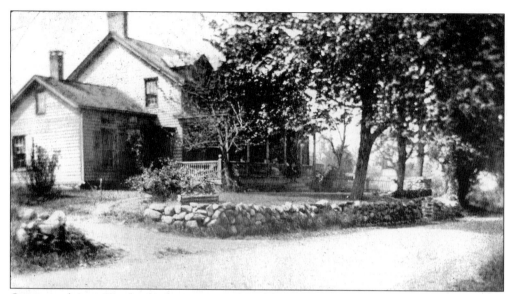

Garrett and Ann Quackenbush are seen at their house on Russell Avenue c. 1910. The couple lived in this house until 1942, and then Harold Quackenbush lived in it until the 1970s. The house stands next to Route 208, which was originally called Arcola-Oakland Highway S-4.

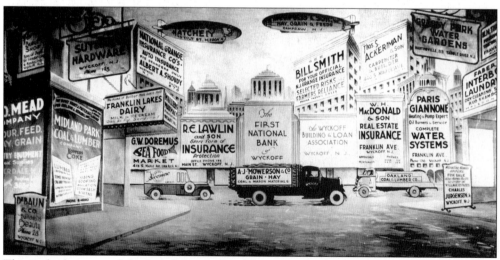

This is the large mural that was hung at the old Grange. It is a collage of local businesses and was recently discovered in storage by the Wyckoff Historical Society.

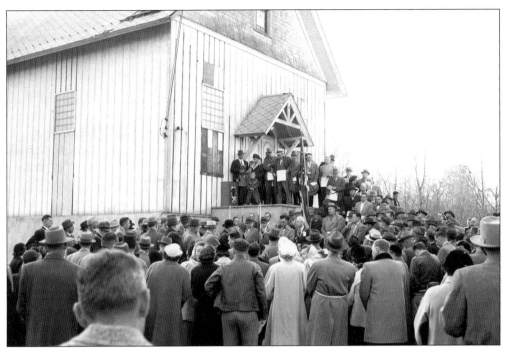

This is the old chapel from the Wyckoff Reformed Church that was moved through town to Main Street. The Masonic dedication took place in 1954.

Seen here is the dedication of the new Fire Company No. 1 station house by the town hall. The locomotive wheel rim was used to ring the alarm in the early days of the fire department.

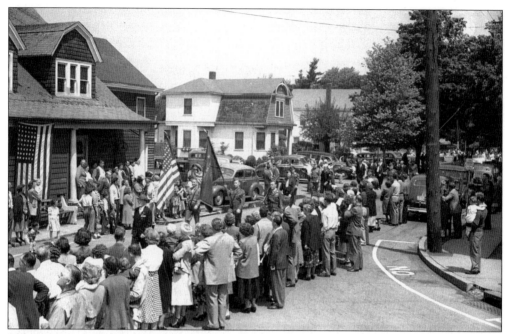

The 1952 town Memorial Day parade goes past the Brownstone. This parade has always been an important event for the town to honor those who fought in the armed services.

The 1956 Ramapo football team is seen in this view. Ramapo and Indian Hills are the two regional high schools that take students from Wyckoff, Franklin Lakes, and Oakland.

The 1956 school band had a large accordion section. Apparently, the accordion was very popular with the children in the 1950s.

The Fire Queen beauty contest was held in 1957 for the 50th anniversary of the fire department. Each company had a winner, and the overall winner was crowned Miss Fire Queen and then rode in the fire parade.

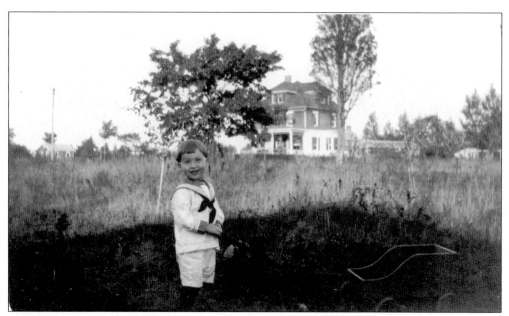

Bruce Scott is seen as a child on Everett Avenue in 1920. Note the rural character of the street. Bruce's two grandfathers, James H. Winters and William C. Scott, were both fire chiefs. Bruce and his father, William E. Scott, served on the fire department for many years. Today, Bruce's son Ed is a fourth-generation Wyckoff fireman.

Created by the chamber of commerce in 1955, *This Is Wyckoff*, a film about the town, was produced by Richard Butler Turner Studios. Most of the original movie has been located and preserved by the Wyckoff Historical Society.

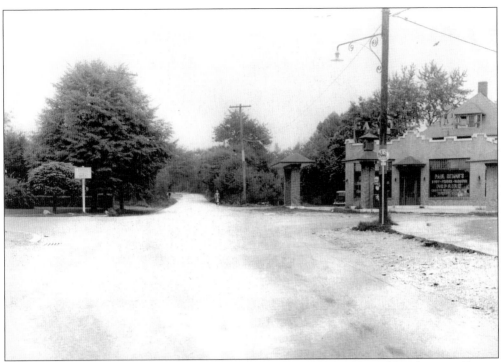

This 1942 view of Godwin and Franklin Avenues looks east on Franklin Avenue. Zeman Motors is the only business visible.

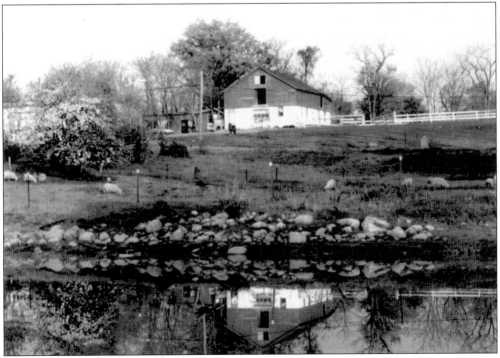

Seen here is the original barn on the Sicomac Farm. A much larger barn was built in order to accommodate the growing dairy business.

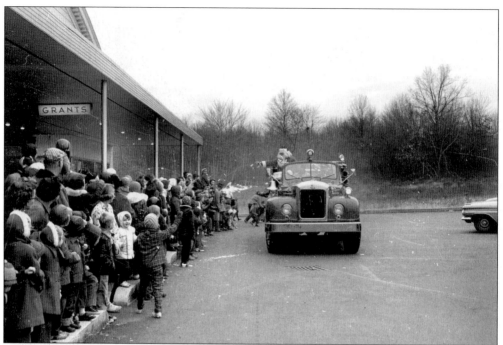

Santa is seen arriving on the fire truck at the W.T. Grant department store. This tradition continues today.

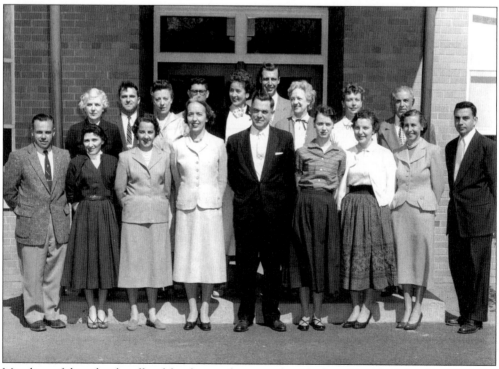

Members of the school staff and faculty are shown at the Abraham Lincoln School in 1956. For a while, Lincoln was a middle school for the town.

Shoppers crowd the store during the W.T. Grant department store grand opening in the Wyckoff Municipal Shopping Center (now Boulder Run) in 1958.

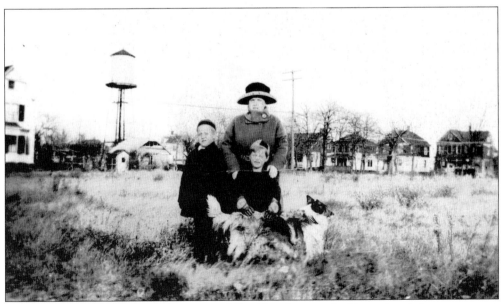

This 1920s photograph provides a view of Franklin Avenue, looking toward the water tower that used to be near downtown.

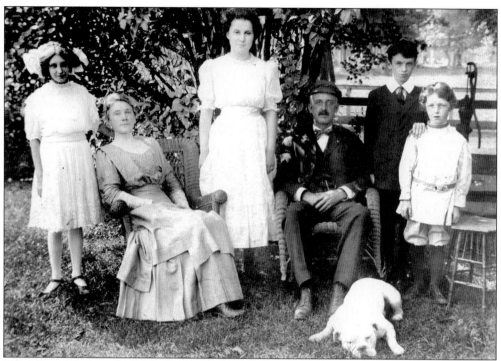

Harry Frost is surrounded by his family. Frost was one of the founders of the fire department and active in town affairs.

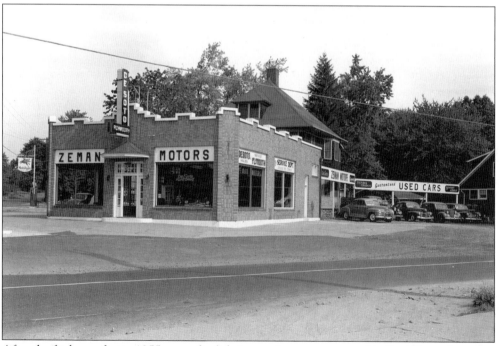

After the firehouse fire in 1955, some firefighting equipment was stored in Paul Zeman's garage. Selling DeSoto cars, Zeman's was situated at Franklin and Godwin Avenues where DeFino Real Estate is now.

Five

DOWNTOWN

The downtown of Wyckoff evolved slowly from its early beginnings. Probably the first commercial establishment was Board and Stout, at the corner of Main Street, in 1860. It was strategically located at the intersection of two roads. With the arrival of the railroad in 1870, commerce increased along Railroad Avenue, as it was known. The Lawlins building was added, and then other buildings, such as the First National Bank of Wyckoff and the post office, filled in the span of businesses.

The other area of development was near the Brownstone along Franklin Avenue. Across the street from the Brownstone was the Edwards brick building, the Frost building, and the MacDonald building. The Sterling building was farther along Franklin Avenue and housed various establishments, including the police station and library, until it was destroyed by fire in 1998.

Cornelius Vreeland had tried to develop the triangle area into homes when the railroad came to town, but it became the triangle business district. Today, there are few private residences left in this area, although some businesses are using some of the old houses instead of tearing them down.

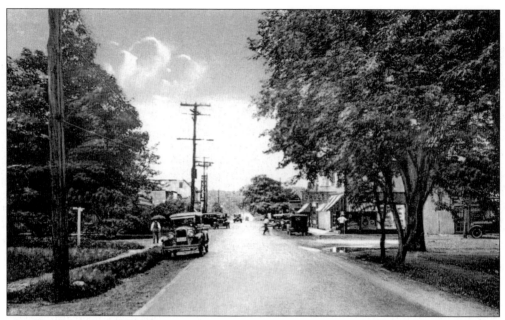

This hand-colored early-1900s postcard looks west on Franklin Avenue. On the right is Benjamin's Drug Store. The Brownstone is hidden in the distance because of the amount of trees.

This is how the downtown district looked in the early 20th century. The view looks west at the intersection of Franklin and Wyckoff Avenues. Note the Brownstone Inn in the background. Wyckoff Auto Sales (by the gas pumps) was established in 1924 by Hugh J. Edwards and eventually became Wyckoff Ford. The actual commercial district consisted of only a few blocks.

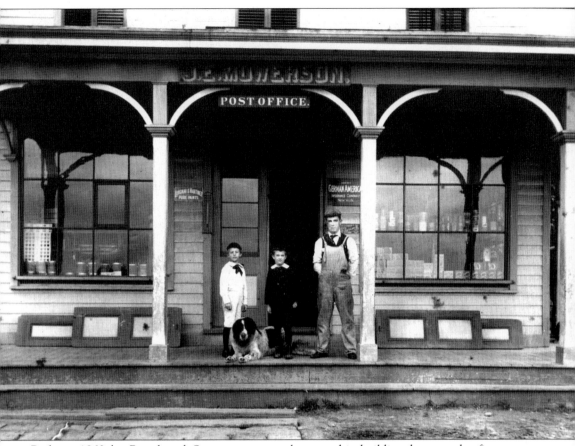

Built in 1860 by Board and Stout as a general store, this building became the first true commercial establishment in Wyckoff. It became John Sloate's general store in 1870, and it became John Mowerson's general store in 1876. The establishment stood at the corner of Wyckoff Avenue and Main Street, facing the train station, and included the barn behind it, which now has a Wyckoff Avenue address. It also served as the Wyckoff Post Office for some time, with John Mowerson as the postmaster. Mowerson sold the business in 1929 to Miller's Drug Store, which still occupies the site. This photograph was printed from an old glass plate.

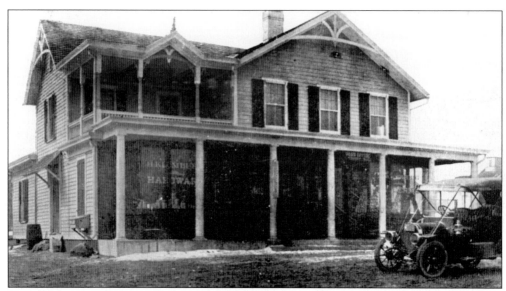

Pictured here is Herman Klomberg Hardware, the Wyckoff Post Office, and the Mowerson grocery store in the Mowerson building *c.* 1914. Herman Klomberg was postmaster at this time. This building became Miller's Drug Store in 1929.

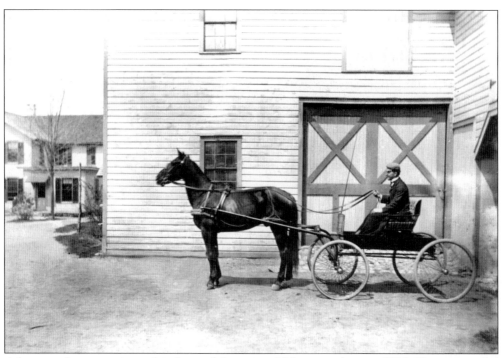

A horse and cart are pictured in front of the original Mowerson barn *c.* 1900. Horses were fed there while people went to Mowerson's general store. The barn would eventually have a Wyckoff Avenue address and was used for furniture and clothing stores.

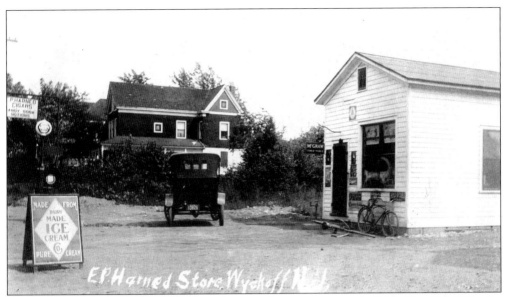

Edwin P. Harned's general store is seen the year that it was opened, 1919. Fire Chief Charlie Parmley's house is in the middle of the photograph. Harned's store was on Franklin Avenue about where Wyckoff Lightings stands today. It was destroyed by a fire in 1922, but Harned was persuaded by the local building and loan association to rebuild and open up another store.

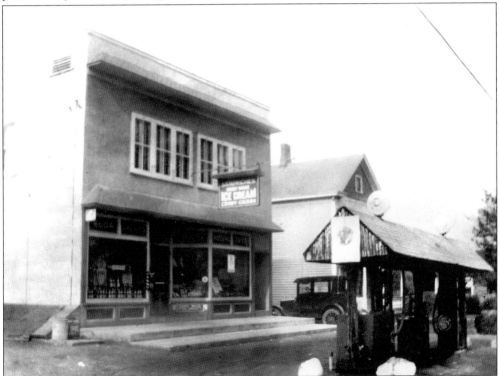

This 1925 photograph shows the new home of Harned's store after the old building was destroyed by fire. The store carried goods as well as a soda fountain. It was a fixture in town until *c.* 1980, when it became the Ivy Shop. Note the gas pumps on Franklin Avenue.

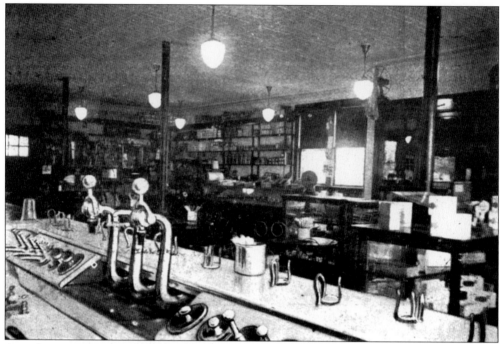

An advertisement in a 1923 booklet lists "fresh dairy ice cream, sodas, chocolates, cigars, notions, groceries, bakery good and novelties for the children." The fountain was made of imported German silver and needed to be polished at least once a week. The seltzer was homemade by the Harned family.

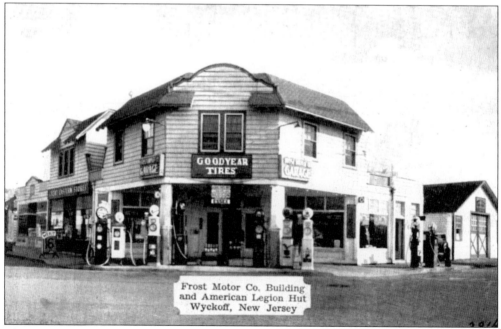

Frost Motor Co. Building
and American Legion Hut
Wyckoff, New Jersey

The Frost building was erected in 1929 to house the Frost garage. Naugle Motors, a Dodge-Plymouth dealer, occupied this structure in 1935. It now is a kitchen cabinet store. The American Legion post used to meet here.

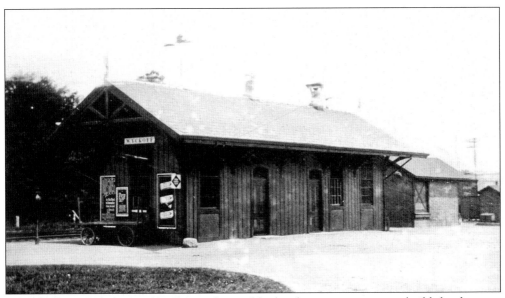

In 1869, $100 and a strip of land were donated by local property owners to build the depot to bring the Susquehanna & Western Railroad through Wyckoff. The provision was that any passenger train using these tracks must stop in Wyckoff. This was a birth of a new era for this small community. A resident recounted, "The railroad came through the center of George Terwilliger's farm, and he was very upset by the center of his farm being condemned by public law."

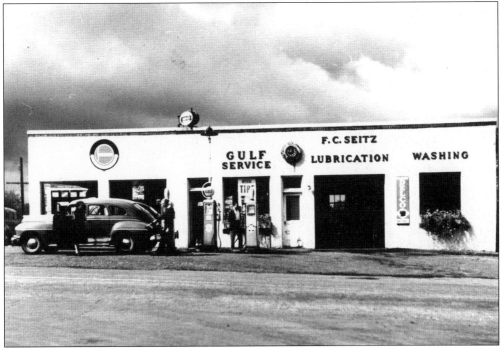

The Seitz garage opened c. 1937 on the corner of Wyckoff Avenue and West Main Street after moving from High Street. Fred Seitz was an active member of the fire department. Today, Wyckoff Tire and Auto Repair is at this location.

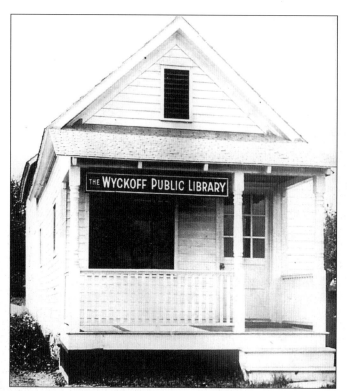

The first Wyckoff library was started in 1921 by an organization called the Women's Work Committee. They formed the Wyckoff Public Library Association. The president was Margaret Rambaut; the secretary-treasurer was Virginia Hubbard; and the vice president was Jennie Arthur Lockwood. The library's first home was a small house rented from Peter Van Houten on today's Main Street. The library opened with 600 volumes, mostly on loan from residents. After moving to Franklin Avenue and then Morse Avenue, the current library was erected on Woodland Avenue in 1970.

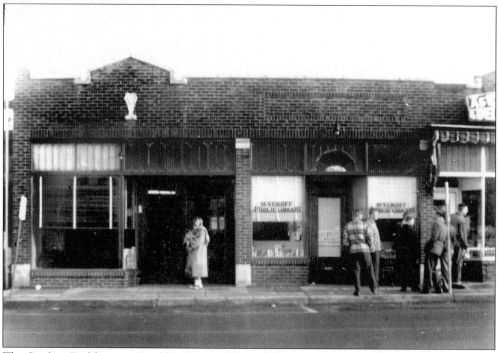

The Sterling Building, on Franklin Avenue, housed the police station, the public library, A & E Deli, and many other businesses in later years. It was destroyed in a 1998 fire. The building was rebuilt and is currently home to a popular Italian restaurant. This photograph is from the 1930s.

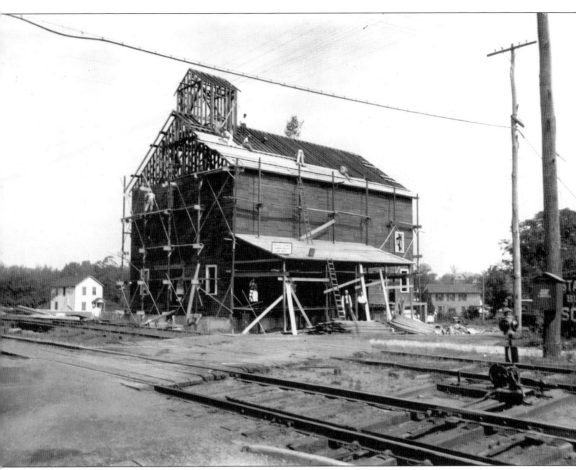

Pictured is the 1917 construction of the A.J. Mowerson feed mill after the old mill burned in 1916 in a spectacular fire that also ignited 400 tons of coal. The coal fire smoldered for weeks before it was extinguished. As the feed-and-grain business diminished, Mowerson became a supplier of stone construction materials. The business has since been sold but continues as Bergen Brick and Tile.

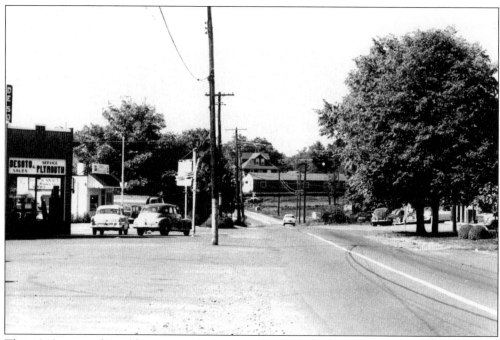

This 1940s view of Franklin Avenue looks west. On the left is the DeSoto dealership and then Bob's Snack Bar. In the center distance is the bowling alley that was added onto the old Wyckoff Hotel. It was taken down in 1955.

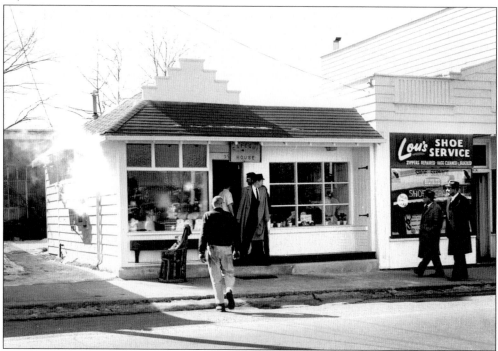

Ca-pa-qui House was named for its three owners, Cambell, Paterson, and Quick. Sitting on Franklin Avenue, it could be classified as a curio shop. There was always a variety of unique goods for sale. It is now occupied by Wyckoff Jewelers.

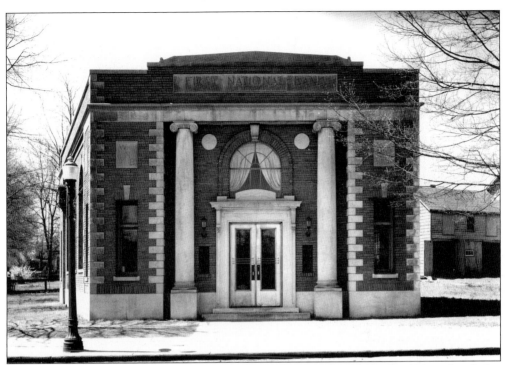

The First National Bank of Wyckoff was founded in 1922, and the bank completed this neoclassical, second Renaissance Revival–style building in 1927. John B. Zabriskie was the first president. Other founders were Herman Klomburg, Peter S. Pulis, William V. Pulis, A.J. Mowerson, Robert Mowerson, F.G. Manwaring, J.M.B. Frost, R.E. Lawlin, and J.H. Rudick. Note the contrast of the modern bank and the rustic barn in the background.

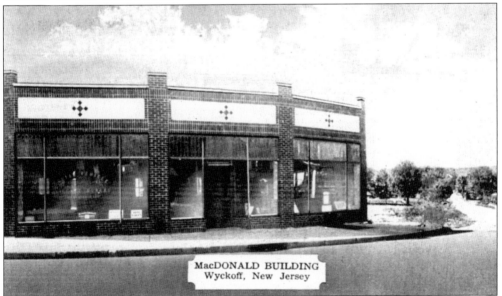

The MacDonald building, at the corner of Franklin and Wyckoff Avenues, was built in 1929. The MacDonald family ran a successful insurance and real estate business from this facility. An optician now occupies the building.

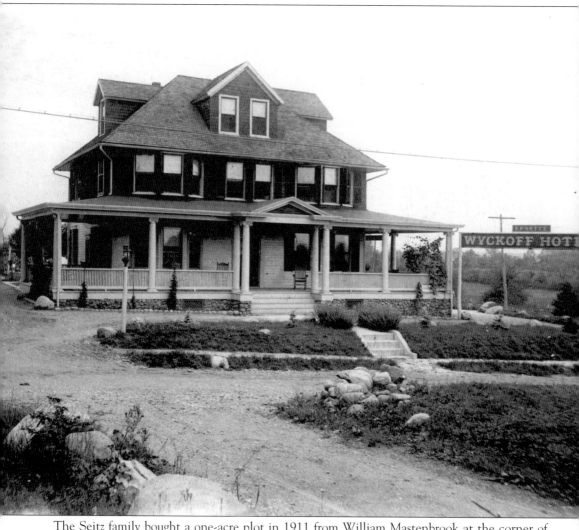

The Seitz family bought a one-acre plot in 1911 from William Mastenbrook at the corner of Franklin Avenue and Main Street and built a hotel. On the first floor, there was a living room, a kitchen, and a barroom. The liquor license was transferred from the old John Ramsey hotel, which burned in 1909 at Russell and Wyckoff Avenues. The Seitz family ran the hotel until 1928. The building then went though several owners, including Edward Vreeland, who took off the porch and added a bowling alley. The building was razed in 1955.

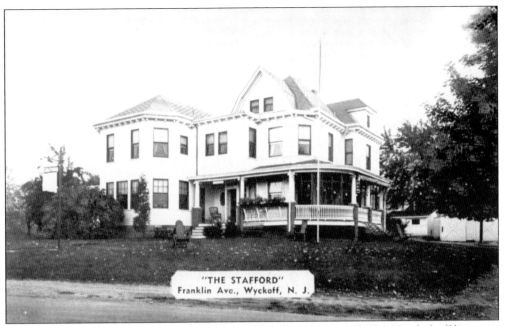

The Stafford functioned as a boardinghouse for Wyckoff. Originally the Vanderhoff house, it was built c. 1920 and managed by Hugh Edwards's sister. It featured a large bar area and hosted social functions in town. The Stafford was at 372 Franklin, where the auto parts store and real estate office are now, and was named for the Edwards family's home town in Kansas.

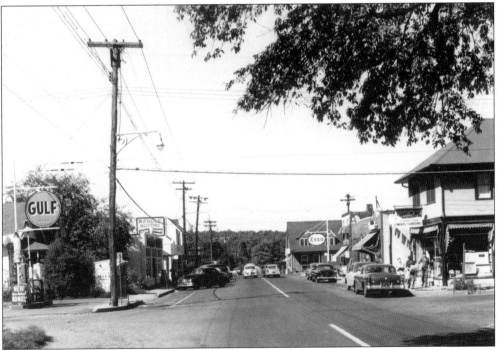

Looking west on Franklin Avenue in the 1950s, you can see MacGregor's Gulf station, a Sicomac milk vending machine, and Naugle Motors. On the far right is the Franklin Avenue Market, which replaced Benjamin's Drug Store.

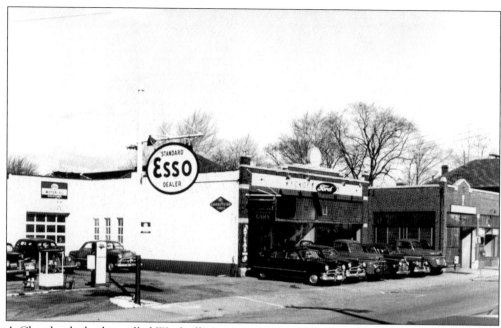

A Chrysler dealership called Wyckoff Motors was started by Hugh Edwards in 1924. This 1954 photograph shows the business after it became a Ford dealership. The early Fords were shipped in pieces, and the local dealer had to finish assembling them. The 1998 fire razed the Wyckoff Ford structure, and a new building was built to house the dealership.

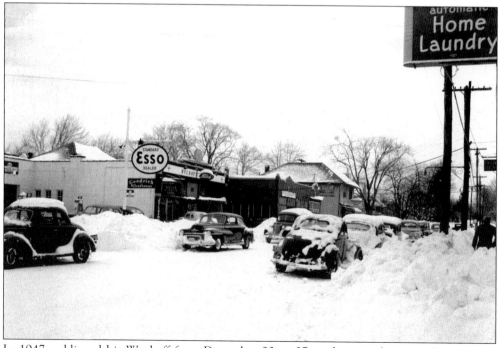

In 1947, a blizzard hit Wyckoff from December 23 to 27, with more than two feet of snow falling. Many people were without power and water for days. This is the view looking east on Franklin Avenue, with Wyckoff Ford to the left.

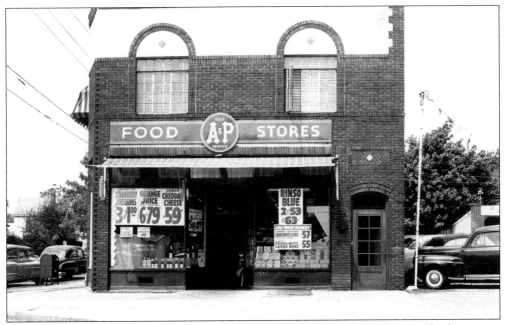

Located across the street from the Brownstone was Edward Gallant's home. The home was moved to Edwards Road in 1929 in order to construct this building. The Gallant building, as it is called, has housed different commercial establishments, including the A & P, the Above the Salt cheese store, and (currently) Pane & Vino. This photograph is from 1956.

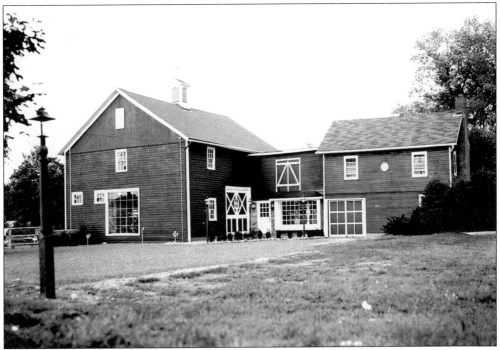

Dormarelle Barn was the old Mowerson barn that was converted into a clothing store in 1950 by Martha Hasslinger and Ellen Koenig. The store has gone through different exterior changes and has had various owners but is still operating as clothing store today.

The interior of Dormarelle Barn used to reflect the rustic interior of its barn heritage, giving the impression that one was actually in an old barn. The wood stove, which provided heat for the barn, is no longer in use.

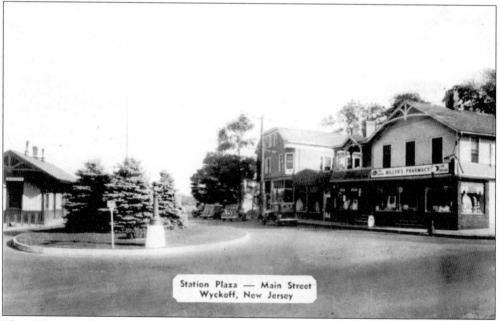

Station Plaza — Main Street
Wyckoff, New Jersey

This old postcard shows the island called Station Plaza, which used to grace the front of the railroad station. It was used in World War II to collect scrap metal to help the war effort. More than half a ton of aluminum was donated by residents, mostly in the form of pots and pans, to help the aircraft industry.

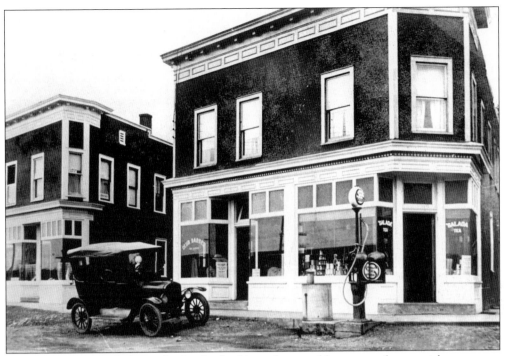

This 1915 photograph shows the Lawlin building, then used by a general store with gas pumps outside, on Main Street. It has also housed Tempel's Market and a law office. Lawlins Insurance operated out of here for many years.

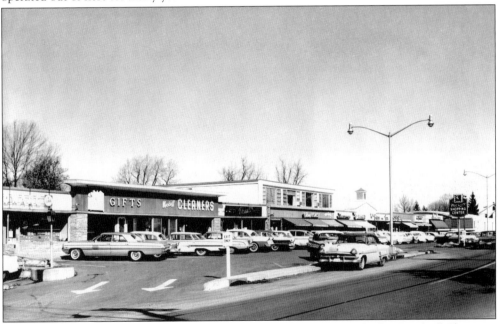

Built in 1952 where the Quackenbush-Honey house used to stand, the Wyckoff Shopping Center was one of the first shopping centers in town. Many businesses have come and gone in the mall, including the Clock hardware, Peter Bakker hardware, the five-and-dime, Vogel Hardware, and others.

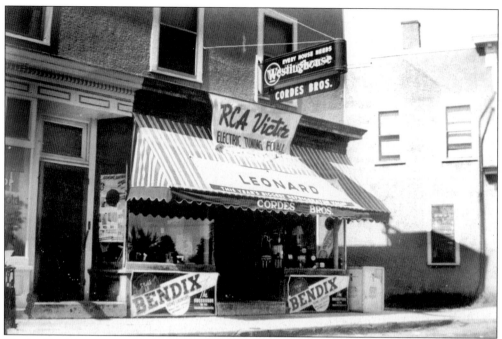

Cordes Brothers was established by Hans and Otto Cordes in the 1930s. Their main business was selling radios and refrigerators. The refrigerator became a mainstream appliance in the 1930s and 1940s.

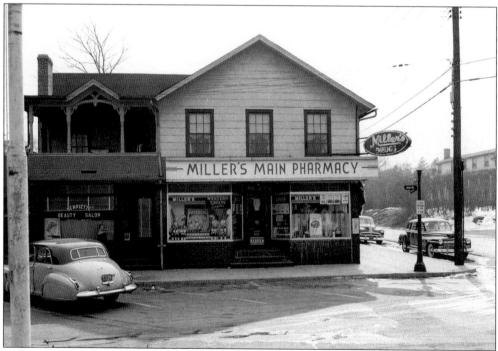

Miller bought the old Mowerson building in 1929 and started Miller's Drug Store (later called Miller's Main Pharmacy). Miller's is still run by the Miller family 70 years later and is at the same corner of Main Street and Wyckoff Avenue.

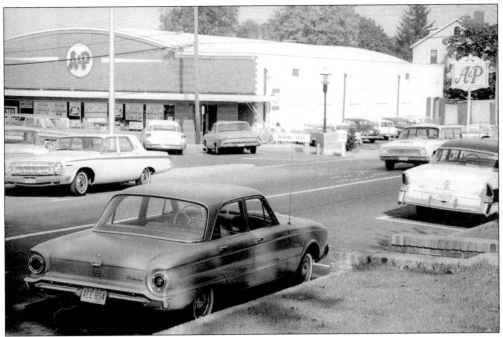

The A & P was at the corner of Clinton and Wyckoff Avenues in the early 1960s. Wine and Spirit World and Beauregard's restaurant later occupied this building. The building was destroyed in a 1998 fire. It has since been rebuilt as another grocery store.

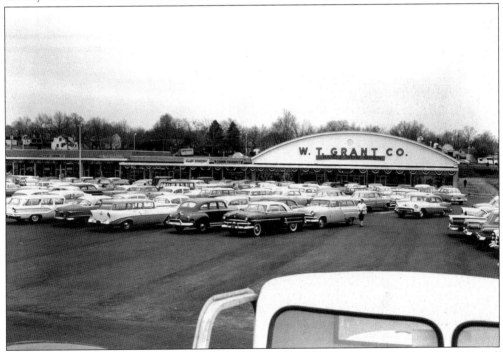

Another large shopping center was built in the 1950s. The original name was the Wyckoff Municipal Shopping Center. A Grand Union was later built at one end, and the center was renamed Boulder Run.

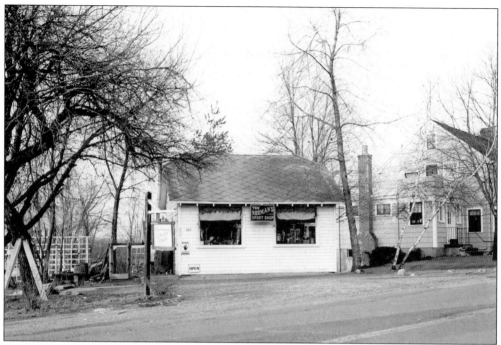

Seen here is a 1954 view of Tom Norman's Sport Shop on Franklin Avenue. Tom Norman Sr. was the first full-time policeman for Wyckoff, and Tom Norman Jr. served on the force (including as fire chief) for 28 years. This is now Frank's Barber Shop.

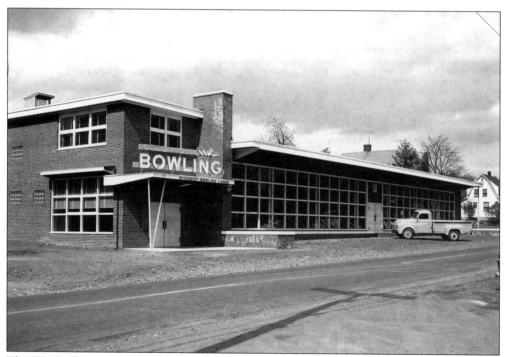

The Wyckoff General Supply Company and the Wyckoff Lanes are pictured in 1953. This is the Donnelly building, which now contains the Sock Factory and a fitness gym.

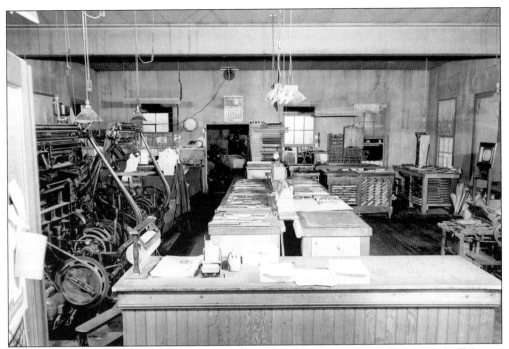

The *Wyckoff News* was the local newspaper for Franklin Lakes, Oakland, and Wyckoff. It was published from 1926 into the 1980s. Seen here are the printing presses that were used for publications.

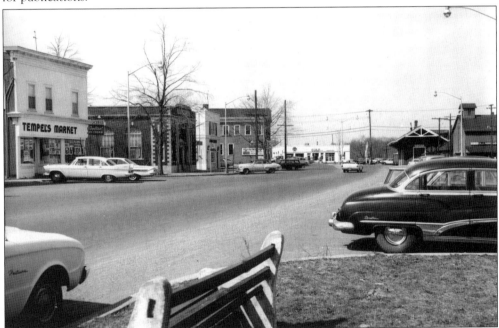

Tempel's Market is on the left in this view of Main Street. Phil Temple had the market from 1926 to 1943. When Tempel was drafted to serve in World War II, the market had to close for a time. Later, it was modernized to provide baskets to shoppers, and the name was changed to Tempel's Market–Self-Service.

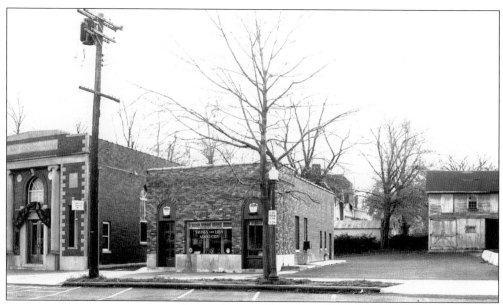

Originally started in 1907 as the Wyckoff Building & Loan, Wyckoff Savings and Loan built its building on Main Street in 1939. The First National Bank of Wyckoff is on the left, and an old barn sits in the background. As an early loan company, the Wyckoff Building & Loan helped many local businesses start their commercial enterprises.

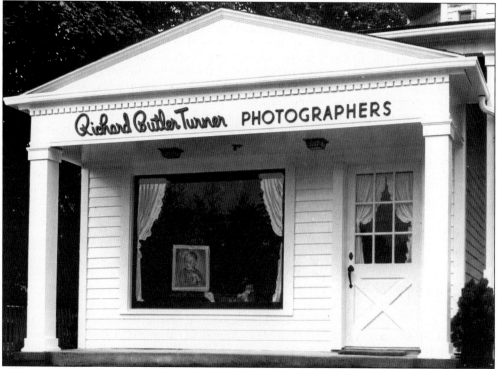

Richard Butler Turner was the principal photographer in town from the late 1940s until the 1990s. He photographed the numerous events around town and has lent the Wyckoff Historical Society many of his negatives. He also took many of the school pictures from around the area.

Six

CHURCHES AND PLACES
OF REST

The church was a powerful influence for the early Dutch settlers. They began attending the Dutch Reformed Church at the Ponds (now Oakland) c. 1710. The church covered a very large area, and the residents in the area decided to build their own church on a half acre of land. The cemetery next to the church was expanded with several additions of land over the years. Eventually, the Wyckoff Dutch Reformed Church (the "Dutch" was eventually dropped from the name) became a separate entity. Attendance at Sunday services was fraught with hardships in those days, such as carriage travel or walking to get there, putting on clean shoes, and bringing foot warmers to stay warm until the building was updated with stoves.

Wyckoff was an attractive place for different faiths to built houses of worship in town. The next church to be established in town was the Church of St. Elizabeth, which built a small church in 1903. Next was the Wyckoff Gospel Mission Church, which built a chapel on Wyckoff Avenue in 1923 and eventually built a new church on Franklin Avenue, changing its name to the Wyckoff Assembly of God. The other houses of worship that followed were the Cornerstone Christian Church of Wyckoff (1957), Second Reformed Church (1958), Advent Lutheran Church (1959), Grace United Methodist Church (1964), Bethany Church (1971), St. Nicholas Greek Orthodox Church (1973), Covenant Protestant Reformed Church (1974), Temple Beth Rishon (1975), Faith Community Christian Reformed Church (1978), Bergen Testimony Church (1986), and the Cedar Hill Christian Reformed Church of Wyckoff (1990). Wyckoff was named in an Associated Press report mentioning the large number of houses of worship for the small number of people residing here.

Legend has it that the Native Americans used to bury their dead near Sicomac Avenue. The Wyckoff Reformed Church Cemetery was an important burial site for the early settlers in town and is an important historical record. There are some very old and intricate headstones to be seen there. The Union Cemetery is the other pre-Revolutionary burial ground in town, and stones date back to the 1760s. It is hidden off Franklin Avenue near the Waldwick border. This cemetery is in the process of being restored by the Wyckoff Historical Society and concerned residents.

There has always been respect for those who lost their lives in the service of their country, and several monuments have been erected in town to honor them. Wyckoff has had a long history of honoring Memorial Day.

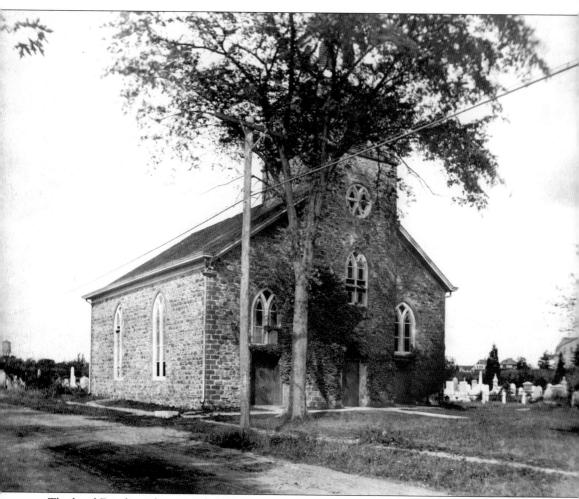

The local Dutch settlers attended the Ponds Dutch Reformed Church, which was built in 1710. When the congregation grew large enough, land was bought from Aaron Ackerman and Albert Van Vorhees for $7.50, and a church was built in 1806. The rectangular stones making up portions of the church were quarried from Red Mills Quarry in the Arcola area of what is Paramus. The local farmers would take their load of produce to the market in Hoboken and would take some stones back in their empty wagon. The church members bought their own pews, with donations ranging from $8 to $82. In this photograph, taken *c.* 1910, the Quackenbush water tower is in the left distance. The tower served the needs of several families and was destroyed by fire in 1926. The old Wyckoff Public School is in the right distance.

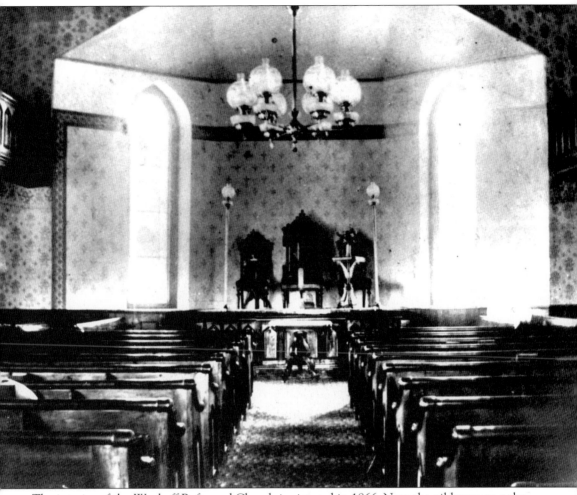

The interior of the Wyckoff Reformed Church is pictured in 1866. Note the oil lamps on poles in front. Electricity did not come to the church until c. 1909. Note the simple altar. Later, a large pipe organ was installed, and more elaborate woodwork is evident.

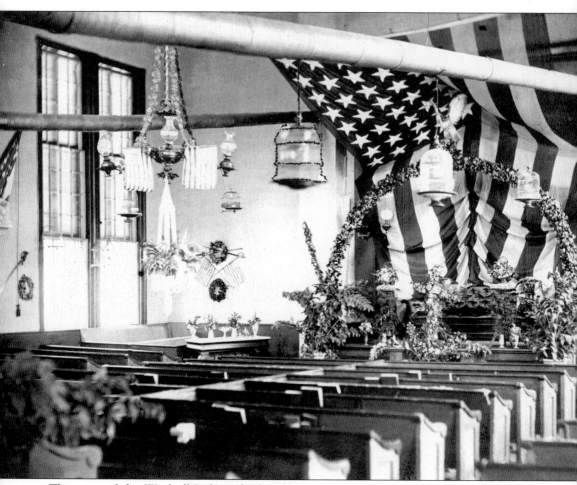

This view of the Wyckoff Reformed Church interior is purported to be from c. 1910. The stovepipes ran through the main space of the church to provide warmth and were installed in 1829. The only heat prior to that were foot warmers brought by members of the congregation. The stoves were removed and furnaces for steam heat were installed in 1906.

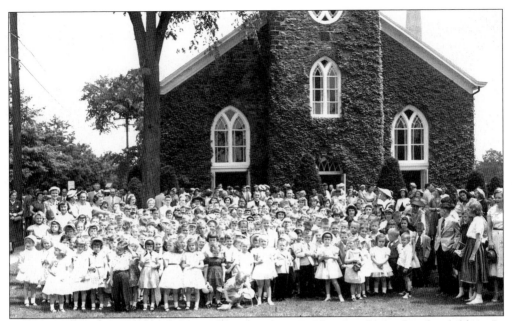

Children's Day at the Wyckoff Reformed Church was a celebration devoted to the children. In the back, the left and right doors to the church were not there originally, but they were added when the galleries were lowered in 1865. The Wyckoff Reformed Church is only one of eight stone churches left in Bergen County and unique due to the amount of fieldstone used in its construction.

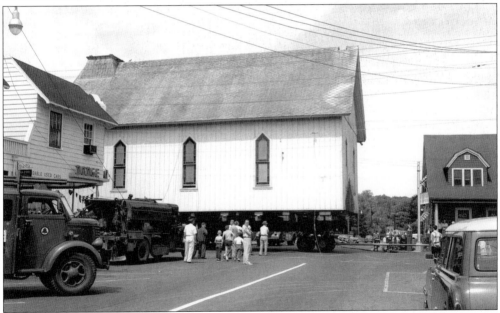

In 1954, the Wyckoff Reformed Church gave a small chapel that had been built in 1896 to the Masonic lodge. It had to be moved through the center of town to its destination on Main Street. A crowd developed to watch the building's progress through town while power lines were moved and trees trimmed. The Scottish Highlanders donated a cornerstone for the building. The chapel building was later faced with brick and is still on Main Street.

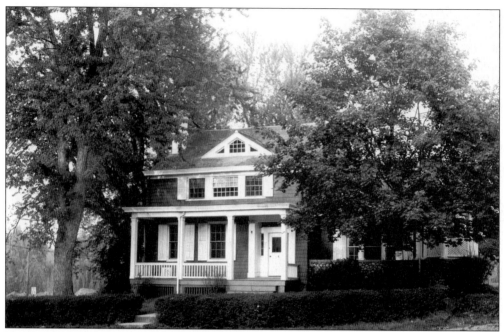

Used as the parsonage house for the Wyckoff Reformed Church, this structure was built c. 1849 at a cost of $1,500 on two acres purchased from Corines Quackenbush. It stood on Wyckoff Avenue near Clinton Avenue, approximately where the supermarket is now. This picture shows the house in 1955, shortly before it was demolished.

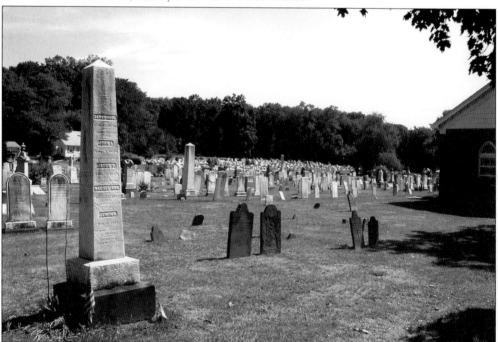

The Wyckoff Reformed Church had been using the land next to the church as a cemetery since it was built. One acre was purchased in 1856. It gradually expanded, and in 1935, seven more acres were added to the cemetery, and a cemetery association was formed to maintain it.

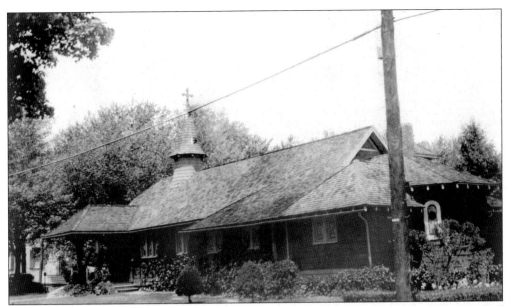

The first Catholic residents would meet in private homes, the firehouse, and the Wyckoff Reformed Church. The parish was formed in 1902. The number of parishioners increased, partly due to the number of summer workers and farm hands. Their first building was completed in 1903, at the corner of Clinton and Everett Avenues, and enlarged in 1912.

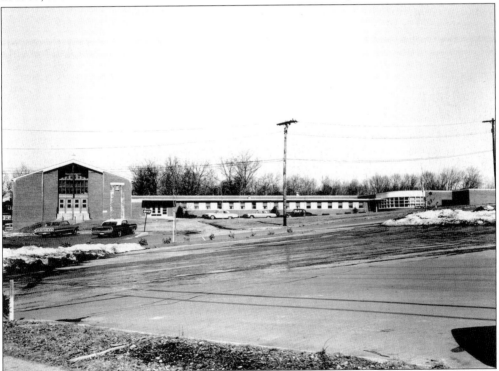

Increasing numbers of members led to the building of a new church, auditorium, and school on Greenwood and Wyckoff Avenues in 1954. The bell from the old church was preserved in a stand in front of the church. Another large addition was completed in 1992.

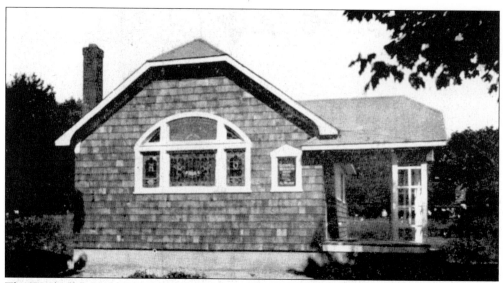

The Wyckoff Gospel Mission was first organized in 1909 as a nondenominational church. The Wyckoff Gospel Mission church was built in 1923 on Wyckoff Avenue, across from the Brownstone. In 1943, they joined the Assemblies of God. When they outgrew this building, land was purchased in 1967 on Franklin Avenue, and the new church was completed in 1970. The old parsonage building was moved to the back of the new property. The old church is still standing and is used as a commercial building.

Erected in 1928 in front of the Wyckoff Reformed Church, the war memorial was dedicated to the residents who served in World War I. Later, names were added for those who died in World War II, Korea, and Vietnam. The original bronze plaque is in the town hall, and the monument was engraved to reflect all wars through Vietnam. Many of the names have been used to name streets in Wyckoff. It is the focal point of the Memorial Day parade each year.

The Union Cemetery dates back to the first half of the 1700s, when Johannes Van Blarcom set aside an area of his property to become a burial place. The earliest readable stone is from 1764 and thought to mark the grave of a slave girl because there is no surname given. Johannes Van Blarcom's daughter, who died in 1725, is alleged to be buried there also. Various community groups have volunteered to maintain the cemetery, including the Wyckoff Historical Society.

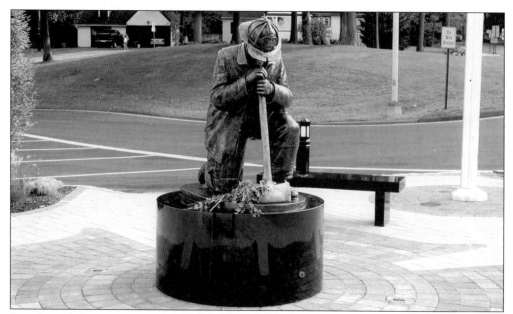

Seen here is the memorial to Dana Hannon, who grew up in Wyckoff and was a member of the Wyckoff Volunteer Fire Department for 11 years. Hannon had joined the New York City Fire Department in 1999 with Engine Company 26. His company responded to the World Trade Center attack on September 11, 2001, and he perished in the north tower collapse.

This is the memorial to the 11 Wyckoff residents who died in the September 11 attacks. They were Thomas H. Bowden Jr., David Brian Brady, Dana Rey Hannon, Alan K. Jensen, Shari A. Kandell, Thomas Kelly, Sara Elizabeth Manley, Scott M. McGovern, Craig A. Silverstein, Richard J. Todisco, and Roy M. Wallace.